IMAGES
of America

OHIO'S LAKE ERIE WINERIES

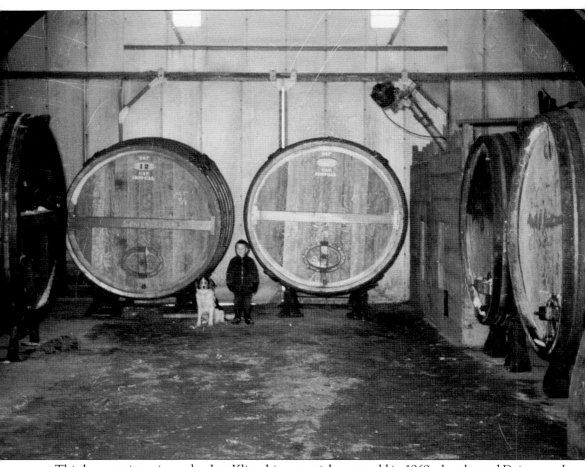

Third-generation winemaker Lee Klingshirn was eight years old in 1969 when he and Daisy posed for this picture. These casks in his family's wine cellars in Avon Lake were inherited from the Hommel Winery in Sandusky. Winery families often work with and learn from other grape growers and winemakers. The story of Ohio's Lake Erie Wineries is about heritage, hard work, passion, neighborliness, love of nature, and romance. (Courtesy of the Klingshirn family [Klingshirn].)

ON THE COVER: Sandusky's annual Grape Festival celebrated the area's heritage as a leading wine producer in the nation in the late 19th century. Right before Prohibition, the Sandusky area was third in the nation in wine production. Dorn Winery's 1941 float festooned with grapes and beautiful girls cruises through the center of town while the proud community watches. (Courtesy of the Sandusky Library.)

IMAGES
of America

OHIO'S LAKE ERIE WINERIES

Claudia J. Taller
Foreword by Lee Klingshirn

ARCADIA
PUBLISHING

Published by Arcadia Publishing
Charleston, South Carolina

Printed in the United States of America

Library of Congress Control Number: 2010943011

For all general information, please contact Arcadia Publishing:
Telephone 843-853-2070
Fax 843-853-0044
E-mail sales@arcadiapublishing.com
For customer service and orders:
Toll-Free 1-888-313-2665

Visit us on the Internet at www.arcadiapublishing.com

*To Paul, who shares my wine country journeys, and to grape growers
and winemakers in Ohio's Lake Erie Appellation—you inspire me.*

CONTENTS

ACKNOWLEDGMENTS

Five years ago, I received Patricia Latimer's *Ohio Wine Country Excursions* as a birthday gift from my husband, because we loved romantic weekends in New York's Finger Lakes. Latimer brought Ohio's vineyards and wineries alive. We started out with a map of wineries and covered bridges in Ashtabula County and were surprised by dirt roads less than an hour from Cleveland. We encountered beautiful vistas, engaging and impassioned enologists, and family-farm stories. I am thankful to have learned about a well-lived lifestyle close to home.

I acknowledge all those living life amongst vines and wines, those noble folks who know the power of sharing the fruit of the vine and have a gift for hospitality—those who own vineyards, run wineries, and make excellent wines. When I began work on this book, I heard stories about trellising systems and late frosts, good and bad grape years, experiments with oak barrels and screw tops, and how the wineries kept working at producing good wines. They patiently answered questions and let me take pictures and corrected my mistakes, and they gave me pictures from their private collections.

I thank the historians and preservationists who opened their records for inspection and provided me with images. They include the R.B. Hayes Presidential Center, Kelley's Island Library, Michael Gora of Middle Bass Island, the Ohio Department of Natural Resources, the Ohio Historical Society, the Sandusky Public Library, the Westlake Porter Public Library, the Cleveland State University Memory Project, the Cleveland Heights Library/Community Congress, the Cleveland Public Library's Cleveland Press Collection, the Ohio Wine Association, and Gayle Absi.

Arcadia Publishing editors Melissa Basilone and Bobby Kangas have been patient, helpful, and responsive throughout the process of putting this book together. Their guidance is appreciated.

My writing-group friends, my wine-loving friends, my book-group friends, and my Artist's Way friends, as well as my family, encouraged me to go forward with this project, and I am grateful for their support. I especially thank my husband, Paul, for giving me Patricia Latimer's book, for joining me on wine country excursions, and supporting my efforts in writing the story of Ohio's Lake Erie wineries.

FOREWORD

As a child, my early memories are of playing on the dirt pile from the backyard excavation of the wine cellar, taking walks with dogs through fields, stealing Dad's chocolate-covered peanuts from his trimming basket (energy food for long, cold winter days in the field), and friendly, happy people coming and going.

As an adolescent, I pulled trimmed brush from the trellis in the freezing cold, getting whipped in the face, slipping and sliding on rough frozen ground. Strapped into the tractor seat for hours on end, I bounced over rough-plowed ground. I cleaned tanks and barrels, washed bottles, and unloaded, by hand, semi-loads of glass in cartons. When Dad expanded, I installed ceiling fiberglass insulation and panels and itched all day—for many days. I knew the wonderful aroma of ripening Concords, music made by the bubbling fermenters in the cellar, and friendly, happy people who continued to come and go.

I could not imagine a different career path. I developed a love for wide-open spaces, communing with nature, and enhancing the land with my hands. Off to college I went to learn how to grow grapes and make wine. The greatest lesson learned had nothing to do with the craft (grapes ferment the same the world over), but about passion. Wherever I went, passionate growers and vintners always seemed to be surrounded by those friendly, happy people.

Back home, people were coming in fewer numbers, and Dad doubted the business could support two families, but the grass never grew under his feet. He was actively promoting "Ohio" wines with the remaining passionate winemakers left in the state. I was privileged to get to know some of the most motivated people in Ohio's wine industry: Ken Schuster Sr., Bob Gottesman, Lou Heineman, Arnie Esterer, and Drs. Gallander and Cahoon at the Ohio Agricultural Research Development Center (OARDC), just to name a few. Yet the glue that holds the industry together, the queen of Ohio wine passion, is Donniella Winchell, executive director of the Ohio Wine Producers Association (OWPA). Through collective efforts, new and greater numbers of those friendly, happy people have been visiting our establishments.

If anything can be more rewarding than friendly, happy people coming to enjoy the fruits of my labor, and paying for it, I don't know what it is. So maybe it wasn't too crazy to follow in Dad's footsteps after all.

—Lee Klingshirn,
Third-generation winemaker and proprietor of Klingshirn Winery

INTRODUCTION

Ohio is in the midst of a grape-growing and winemaking revival. East of Cleveland, Ashtabula County is home to over half of the wine grape acreage in Ohio. West of Cleveland, the Lake Erie Appellation's rich history in winemaking began in the early 19th century when European immigrants discovered Lake Erie's moderating climate.

Ohio produced more wines than any other state during the mid-1800s, primarily because Nicholas Longworth cultivated 1,200 acres of Catawba grapes on his Ohio River Valley estate. Wine expert Leon D. Adams wrote in *The Wines of America*, "In 1859, Ohio was *the* premier wine state, producing nearly 570,000 gallons yearly, more than a third of the national total, twice as much as California." When southern Ohio grapes started to rot on the vine due to cobwebby powdery mildew, Lake Erie became the primary area for wine production in the state.

Grapes and wines were part of the lifestyle of the farmers on the Lake Erie Islands. The Erie Islands, or "Wine Islands," have a 190-day growing season, the longest in the northeastern United States. Production increased as entrepreneurs came to the area. But when land became more valuable and was put to other uses, vineyards disappeared.

Ohio's wine industry languished at the turn of the 20th century. Many wineries continued to produce product for local consumption, but the number of wineries significantly diminished. The temperance movement discouraged winemaking, and Prohibition destroyed the wine industry in Ohio. But a small number of farms along Lake Erie's shore continued to grow grapes to sell at the Welch's depot or to consumers in the form of juice. Winemaking went underground, and consumption increased, but the quality suffered.

In the 1960s, Ohio's winemakers, or enologists, were influenced by the passionate efforts of Californians to cultivate hybrid and vinifera grapes and by Dr. Konstantin Frank of New York's Finger Lakes region, who learned how to cultivate vinifera grapes in New York. Wineries learned to work with the sandy or clay soil nature provides to create noble wines with subtle character distinctions that Lake Erie's climate and growing conditions bring to the fore.

Today, more than 40 wineries range along Lake Erie's shore and on the islands. Chardonnay and Cabernet grapes grow alongside native Concord and hybrid Catawba. The lure of a romantic and self-sufficient lifestyle leads new viticulturists and enologists to follow their dreams every year. In the community of wineries, everyone is a friend.

One

LAKE ERIE ISLAND ROOTS

Nicholas Longworth, the grandfather of winemaking in Ohio, gave Philip Vroman of South Bass Island Catawba grape stock, which gave birth to Lake Erie islands' Catawba Vineyards. The misunderstood Catawba grape was thought to be a native American grape, but it was an intentionally cultivated accidental hybrid. When Europeans discovered Ohio's Catawba grapes in 1802, they began calling North America "Vinland." In 1858, *The Illustrated London News* described Catawba wine as "a finer wine of the hock species and flavour than any hock that comes from the Rhine."

Lake Erie's breezes keep wetness at bay, the moderating temperatures of the lake mean late frosts are infrequent, and its warm waters in the fall allow for a longer growing season. Grapes in the Lake Erie Appellation, the viticultural district of Lake Erie's shore and islands, stay on the vine 10 to 20 days longer than in other grape-growing regions.

Grapes were first planted on Ohio's Lake Erie Islands by European immigrants who made wine part of their lifestyle. Vineyards were well established on Kelley's Island and the Bass Islands by the 1840s, mostly by those of German heritage who believed, as Goethe said, "Wine properly used mellows the mind, soothes the senses, accelerates the imagination, and multiplies the power to concentrate." The remnants of press houses and wooden barrels, and even ruins of stone walls, remain today. Island visitors can learn about the history of the islands at Lake Erie Islands Historical Center at Put-in-Bay and take walking tours of South Bass Island and Kelley's Island, where history can still be found.

Wineries start with the grapes. The Catawba is easily cultivated and makes a more acceptable wine than the musty native grapes of Ohio, like these Concord on the property of Mon Ami Historic Restaurant and Winery in Port Clinton, established in 1872. Grapevines found in backyards and along roadsides in Lake Erie shoreline areas are usually old Concord vines dating back to the 19th century. (Author's collection [Author].)

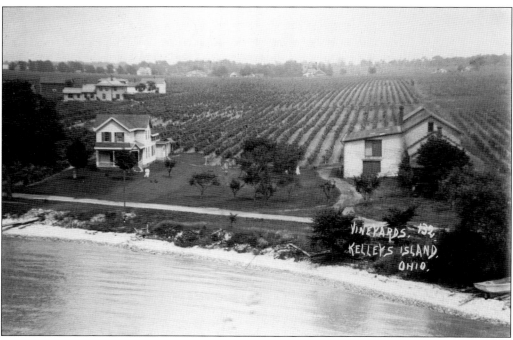

Datus Kelley planted Isabella grapes in 1842 and founded the winemaking industry on Kelley's Island. In 1845, Kelley's son-in-law Charles Carpenter began operating the first commercial winery on the island. The Kelleys' efforts encouraged other immigrants to move to the Lake Erie Islands. Settlers from Germany, Canada, and New York bought lots outright or bought in lease installments with profits from their harvest. (Courtesy of the Charles E. Frohman Collection of the R.B. Hayes Presidential Center, Fremont, Ohio [Frohman].)

The islands were sporadically occupied until the middle of the 19th century. Roswell Nichols and his family became the first settlers on North Bass Island in 1844. In 1854, Spaniard Jose de Rivera Jurgo bought South Bass, Middle Bass, Gibraltar, Ballast, Sugar, and Starve Islands from the Edwards family for $44,000 and cultivated South Bass vineyards for grape production and winemaking in 1858. (Courtesy of North Bass Island.)

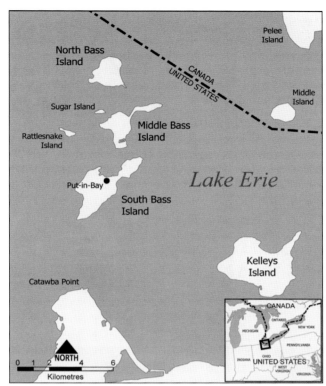

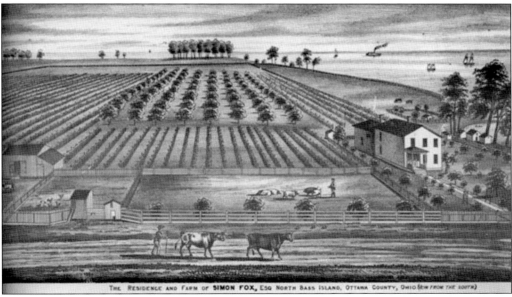

Grapes were planted in rows eight feet apart and trained over trellises held by cedar posts. In 1853, French Canadians Simon and Peter Fox purchased property on North Bass Island and grew Concord, Delaware, and Catawba grapes. This drawing of the Simon Fox residence dates to the time when the Fox brothers settled on North Bass and shows vineyards, orchards, and livestock. (Courtesy of the Ohio Department of Natural Resources [ODNR].)

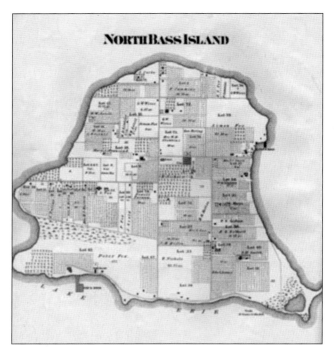

Island life in the mid-1800s flowed with the yearly cycle of the grapevines that budded in the spring, came into full-blown wide, green leaves in the late summer, and produced succulent bunches of grapes in early fall as the leaves began to yellow. Life included harvesting grapes, fermenting wine, and drinking wine with dinner in the European tradition. This map shows the later cultivation of North Bass Island. (ODNR.)

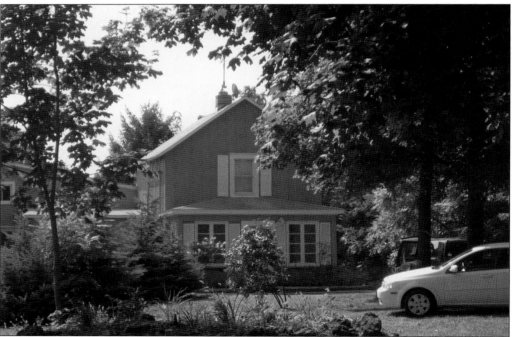

Grape growing and winemaking began on South Bass Island in the early 1850s. Jurgo's winemaking operations took place in this building on South Bass. He was a millionaire who laid out roads and subdivided South Bass before he went bankrupt in 1886, at which time he sold his South Bass Island holdings to creditors, including Valentine Doller, whose home still overlooks Put-in-Bay harbor. (Author.)

Phillip Vroman, Jose de Rivera's agent on South Bass Island, was the first to grow the hearty Catawba grapes on the island after receiving them from Longworth. Vroman grew up in a home on Concord Road in Put-in-Bay. Around the same time, German vintner Charles Miller built his home at Thompson and Put-in-Bay Roads. He arrived on South Bass in 1865 and established his winery. (Author.)

German Christian Engel came to South Bass Island in 1868 and promptly planted vineyards. His home on what is now Langram Road, across from the airport, was built in 1872 and was occupied by his son Christian, grandson Herbert, and great-grandson Robert. As on most farms, wine was pressed on the ground floor of a frame winepress house, and fermentation took place in the cellar. (Author.)

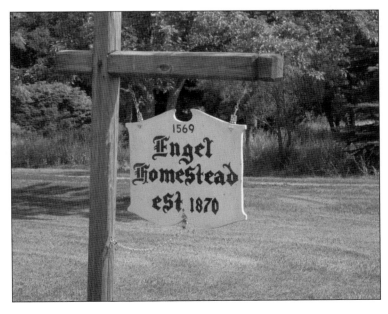

13

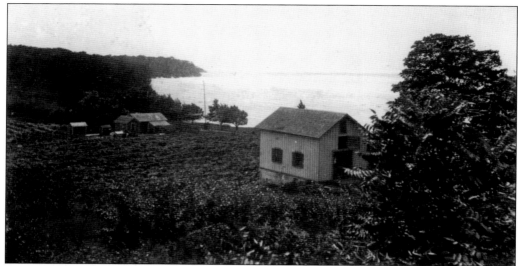

Stones Vineyard on South Bass Island had a picturesque view of Lake Erie from its perch above the water. The Stone Wine Press can still be found on Langram Road near Meechen Road at Put-in-Bay. It was built during the Civil War by Englishman Alfred Parker, who also built the stone house and winepress at Foster Farm in 1860. (Frohman.)

Put-in-Bay, or South Bass Island, hides relics of the previously prosperous wine industry. The Put-in-Bay Wine Company cellar is underneath the former Cooper's Restaurant, now a retail complex. Cooper's Restaurant was built by the wine-producing family of Fred Cooper in 1947 over the former Put-in-Bay Wine Company cellar. It is constructed of limestone from the demolished winery. (Author.)

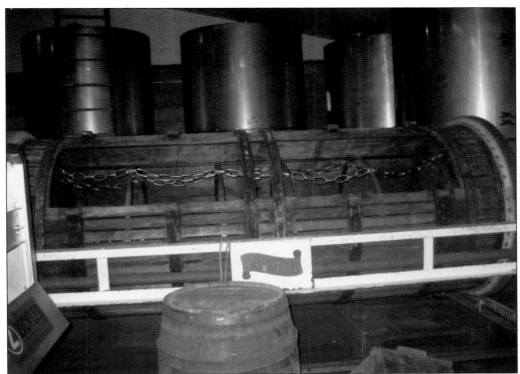

Heineman's Winery, established in 1888, is the oldest continuously operating family-owned winery in Ohio. Gustav Heineman left the Rhine Valley in 1880 and planted Niagara, Delaware, Catawba, and Concord grapes on South Bass Island when he arrived. By 1900, Heineman's was one of 17 wineries with 500 acres of vineyards on South Bass Island. Heineman's winery tour through the caves and the winemaking operations provides a historical perspective of a winery that survived Prohibition. The equipment shown in these photographs is displayed at the winery today. (Both, author.)

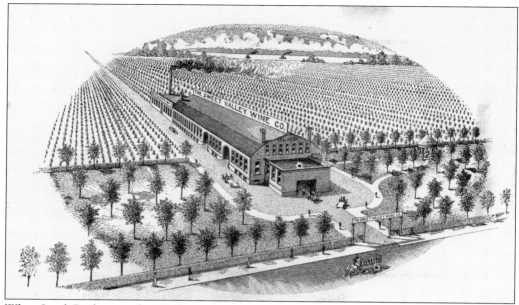

When Jacob Rush arrived on Kelley's Island, he bought 150 acres on which he planted vineyards. His Sweet Valley Cellar No. 1 was built on Kelley's Island in 1857 (this brochure was produced later). Sweet Valley sold North Carolina and California wines (an early example of wine importation) in addition to Lake Erie Island wines. All the wines made by Sweet Valley were fermented in wood. The winery sold Delaware, Elvira, Hock, and others as well as altar wine. (Frohman.)

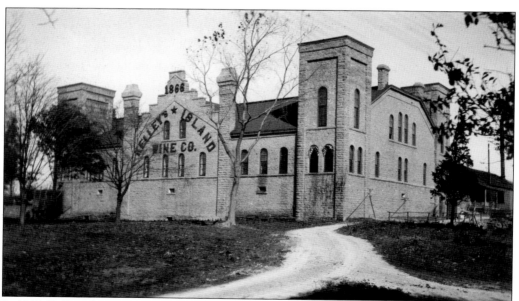

In 1865, Kelley Island Wine Company was formed with Norman Kelley as president. The original 1872 building was destroyed by fire in 1876 and replaced in 1878 by a mammoth stone-walled structure. Grapes were gathered, weighed, taken to the top by a steam-driven conveyor, then crushed and de-stemmed before juice was separated from skins. (Frohman.)

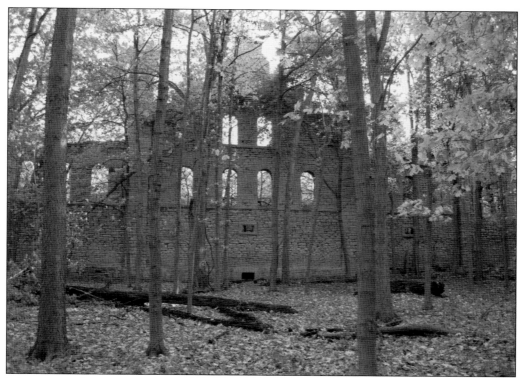

Juice went to fermentation vats and eventually into bottles in two levels of vaulted cellars, which can still be seen on the island. Grapes were sold and shipped as far away as Cincinnati and St. Louis. Some of the finished wine was shipped off the island from a south side dock not far from the wineries. The lands around Kelley Island Wine Company are now covered in new growth trees where vineyards once stood. (Author.)

The impressive solid stone walls of the ruins of the Kelley Island Wine Company remain on the island, with wine cellars and equipment intact. Four large, vaulted cellars on the ground floor, one of which is pictured here, were used for aging and storing the wine. Frank Hauser became the first superintendent of the winery, a position that gave him fortune, for he built a larger, more fashionable home on Water Street. (Author.)

In 1866, the August Schaedler Wine Cellar was built on the southeast shore of Kelley's Island. Schaedler, with his winemaker, Louis Rhein of France, produced Catawba and Delaware wines on the site, starting in 1887 when the winery was bought from John Titus. The arched 65,000-gallon cellar was accessed from the upper levels by a central circular opening. The wine company eventually became known as Schaedler & Rhein Co. Schaedler's success was measured by the magnificence of his home, second only to Addison Kelley's. The closed winery remains on the island. (Both, Author.)

Vineyards covered the Lake Erie Islands, including Kelley's Island, as shown on this 1870 Kelley's Island Vineyards map from *The Illustrated Historical Atlas of Ottawa County, Ohio, 1874.* Island vineyards were known to be more prolific than those on the mainland because Lake Erie's waters surround them. (Courtesy of Kelley's Island Library.)

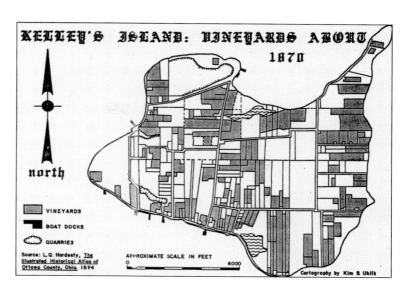

KELLEY'S ISLAND: VINEYARDS ABOUT 1870

north

VINEYARDS
BOAT DOCKS
QUARRIES

Source: L.Q. Hardesty, *The Illustrated Historical Atlas of Ottawa County, Ohio,* 1874

APPROXIMATE SCALE IN FEET
0 6000

Cartography by Kim S. Uhlik

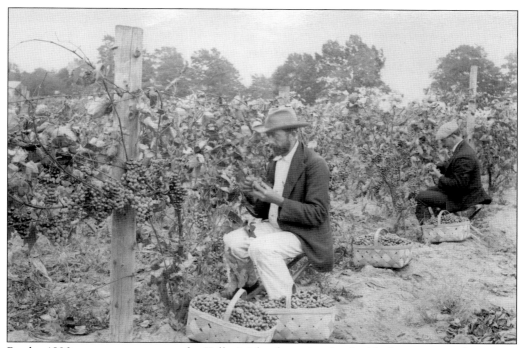

By the 1890s, most everyone on the Kelley's Island was involved with the growing of grapes or making of wine, like James McGettigan, who built a dwelling on top of a wine cellar in the late 1880s. The winemaking business supported a number of other businesses, including an extensive basket industry to contain the crop. (Frohman.)

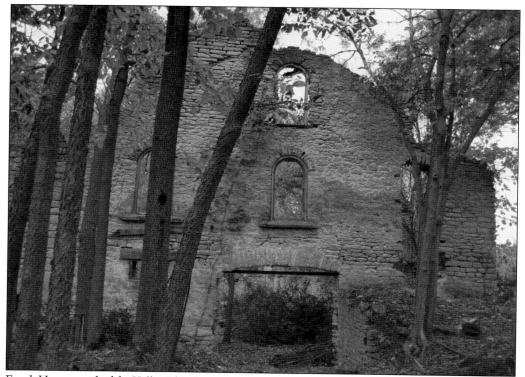

Frank Hauser worked for Kelley Island Wine Company until 1904, when he opened his own Monarch Winery on the former site of Sweet Valley Winery built for the Jacob Rush Winery in 1872. Before the Civil War, it had its beginnings as Rush Winery, which maintained rows of well-made casks and vats. The ruins of Monarch Winery remain on the limestone island. (Author.)

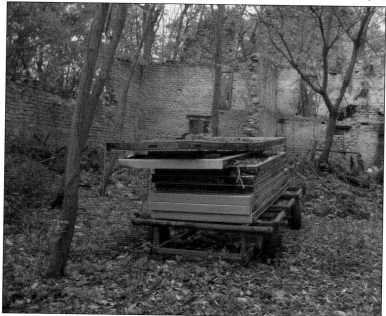

Enlarged in 1880, Monarch Winery's building had a 40,000-gallon capacity. The winery owned 150 acres of Delaware, Riesling, Elvira, Norton, Ives, Concord, and Catawba grapes. In addition to commercial wines, the winery had the capacity for 2,000 gallons of grape brandy and also made sherry, port, and altar wines. (Author.)

Two

ISLAND VINEYARDS INTO THE 20TH CENTURY

The wine industry started with the planting of vineyards, but wineries and their enologists, including Kelley Island Wine Co., Schaedler & Rhein Co., Andrew and George Wehrle, William Rehberg, Gustav Heineman, Frank Hauser, Peter Lonz, Jacob Rush, and James McGettigan, were crafting a lot of wine by the end of the 19th century. As winemaking became big business, cumbersome horse-drawn sleds were used to carry casks of grapes and barrels of wine across the icy lake in winter. By 1900, there were 17 wineries on South Bass Island alone.

People made weekend sojourns from Cleveland to the Lake Erie Islands by wood-hulled ships that trudged through choppy waves parallel to the north coast. The Victorian age may have been a time of propriety, but those with means danced at grand halls built on top of the wine cellars. Despite the revelry, grape growers (also known as viticulturists) and winemakers still lived to the rhythms of the earth into the 20th century.

Ironically, one of the reasons the wineries began their slow decline was tourism. It became more profitable for the land to support development than grapevines. Island life was becoming busier, but not in the vineyards. With fewer grapes, there were fewer wineries. Hardly any of the next generation carried on their ancestral businesses.

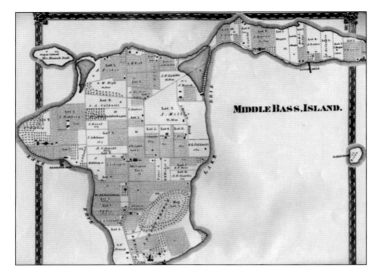

By the 1870s, vineyards accounted for more than half the arable land use on Middle Bass, where peach and plum orchards were also planted. As the population of the island grew, a cemetery, school, and town hall became part of the landscape. Once Wehrle's dance hall was built on top of the wine cellars, Middle Bass Island would become a destination for enjoying an evening of dancing and drinking local wine. (ODNR.)

Middle Bass Island was divided into three spheres of familial influence in the early years of viticulture development: the Lutes family owned the eastern point peninsula, the Wehrle family the southern portion of the island, and the Rehberg family the western portion. They established vineyards and wine production facilities including wine press houses, wine cellars, and docks for easy access to the outside world. (Frohman.)

After Andrew Wehrle bought his portion of Middle Bass Island, he promptly began growing grapes and making wine. Wehrle first pressed grape juice and began to carve out a 14-foot cellar from limestone in 1863. The Wehrle family was instrumental in growing the wine business on Middle Bass, and the "Wine Islands" were known for how well their products stood up to fine French vintages. (Frohman.)

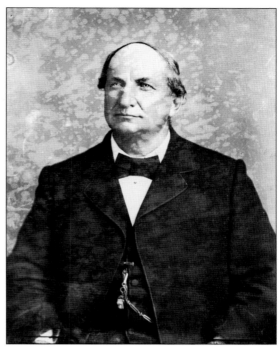

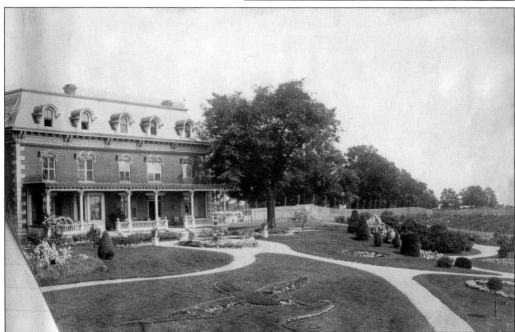

Winemaking was still young on Middle Bass when Wehrle was building his empire. Michael Werk, who started his work in Cincinnati, migrated to Middle Bass Island to join Wehrle as a proprietor of Golden Eagle Winery. The expansive cellar was excavated from bedrock during the period 1863 to 1874, and the winery was built in 1865. Wehrle's home and nearby Wehrle Hall, constructed over the cellar, had southern views toward the mainland. (Frohman.)

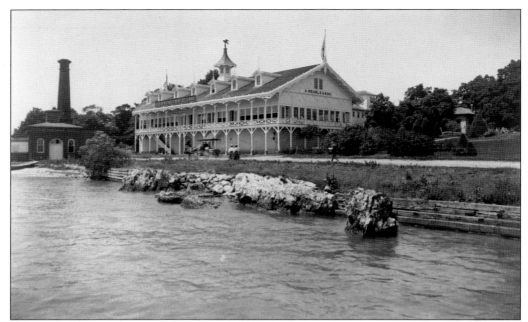

Wehrle's Golden Eagle Winery's capacity was increased to 500,000 gallons in 1872, becoming one of the largest wineries in the country and came to be owned by George Wehrle. The winery was sold to a trustee in 1905, and the home burned down in 1906. Later, the 60-room Hillcrest Hotel was constructed on the site. The winery continued to operate under the leadership of John Roesch, James Hauck, William Conley, and Earl Heinen. In 1923, another fire destroyed Wehrle Hall and Hillcrest Hotel. (Courtesy of Michael Gora, Middle Bass Island [Gora].)

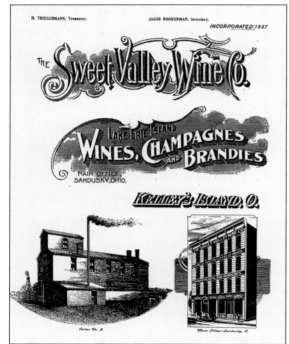

The number of wineries on Middle Bass Island, including Pleasant Valley, established in the 1860s, created competition. With all the commercial expansion, some old-fashioned advertising was required, like this Sweet Valley ad that shows its various wine production buildings. Sweet Valley Wine Co.'s main office was in Sandusky, but its cellars remained on Kelley's Island. (Courtesy of Kelley's Island Library.)

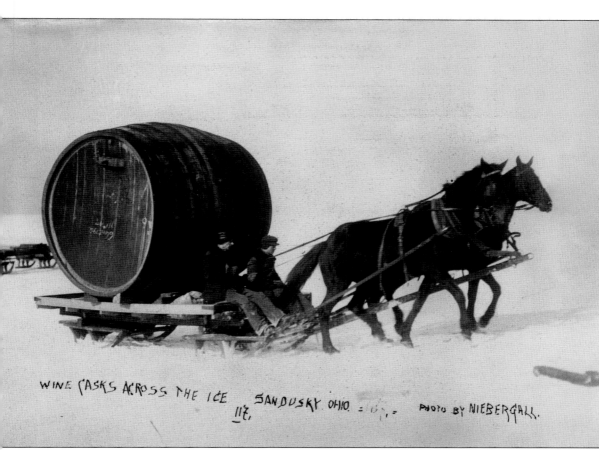

WINE CASKS ACROSS THE ICE SANDUSKY OHIO PHOTO BY NIEBERGALL.

Casks of wine being transported across a frozen lake surface by horse-drawn sleigh is quintessential Lake Erie, where grapes have a longer growing season and the lake freezes over in winter. Island wineries had limited commercial potential unless they were able to transport their wine to the mainland, and weather was no obstacle in the late 1800s and early 1900s. The wine was regularly moved by boat during the summer months, but once Lake Erie froze over, deliveries to customers required casks to be taken across the ice by horse-drawn sled. This 1913 photograph, like other Niebergall images, shows men transporting wine across Sandusky Bay from Monarch Winery on Kelley's Island. (Frohman.)

Sweet Valley, incorporated in 1887, had several cellars. It was doing so well by 1902 that it moved its main winery to Sandusky Bay for proximity to the railroad. It can be assumed that transporting large quantities of wine across Lake Erie to Marblehead Peninsula from Kelley's Island was burdensome, and even Marblehead would have been remote at the turn of the 20th century. (Frohman.)

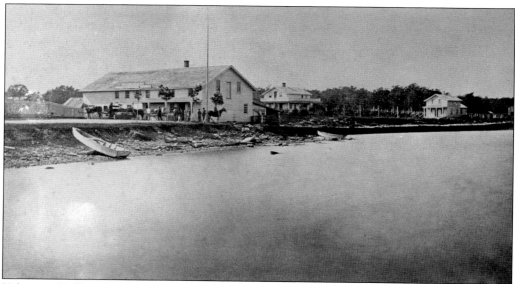

Valentine Doller's South Bass business included a restaurant, saloon, store, telegraph, and post office. Doller's waterfront dock handled a water taxi business at the location where the Boardwalk does today. Doller's vineyards led to establishment of a wine co-op. By the early 20th century, wineries were going out of business, but vineyards did not immediately disappear. (Frohman.)

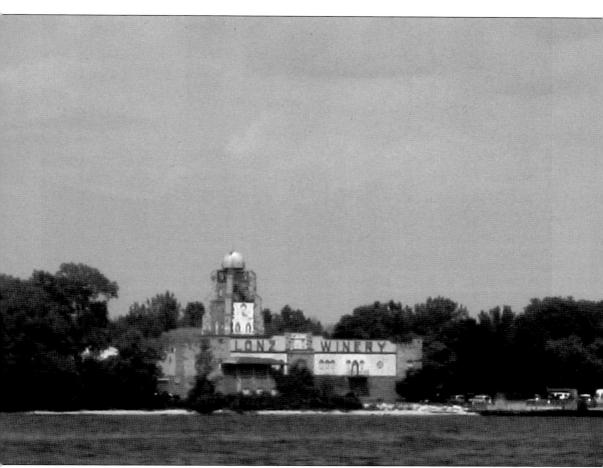

Golden Eagle's winemaker, Peter Lonz, established his own winery on the island in 1884. In 1926, Peter and his son George merged their own winemaking business with the remains of the Golden Eagle Winery. Adjoining the winery, there was a 45-acre vineyard planted by Andrew Wehrle of Alsace in 1862. This is a present-day photograph of the now-vacant winery taken from the ferry that runs from South Bass to Middle Bass. (Author.)

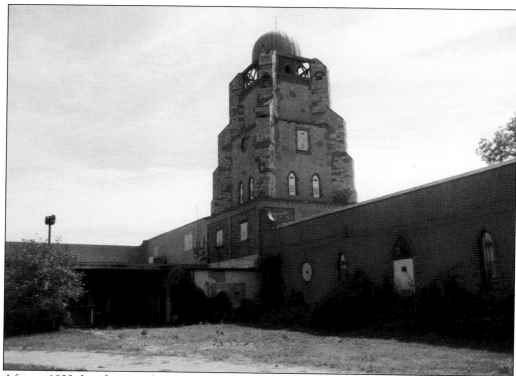

After a 1933 fire destroyed the structure, George Lonz, who has been described both as a bubbling and droll host who entertained his guests with the violin, built the 1942 castle-like winery that became a must-see tourist destination on Middle Bass Island. A modern wine press was built in 1956, and a marina was added to the winery complex in 1962 to accommodate pleasure boaters. (Author.)

George Lonz died in 1969 and was succeeded by Lorito Lazaroney, who came from Hommel Cellars in Cincinnati. The Lonz Winery was placed on the National Register of Historic Places in 1986. (Author.)

A tragic terrace collapse that killed one person and injured 75 others on July 4, 2000, closed the winery for good. Lonz Winery and surrounding buildings, including the old manor house, are now owned by the State of Ohio. The Lonz legacy is carried on by Firelands enologist Claudio Salvador, who makes and bottles Lonz wines. (Author.)

The North Bass Wine Company's cellar is exposed beneath a house on North Bass Island today. (Gora.)

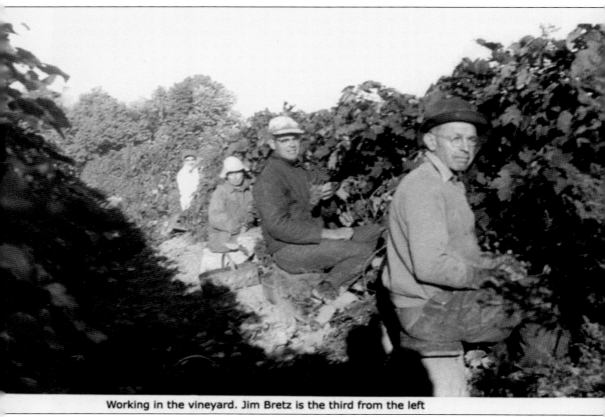

Working in the vineyard. Jim Bretz is the third from the left

Jim Bretz, the owner of Bretz Winery, was still growing grapes and working in the vineyards on Middle Bass Island in 1958. Jim's father, Leslie Bretz, born in 1893, inherited an 1865 wine cellar from Grandpa Joseph Miller. He sold the Catawba, Delaware, Claret, and Concord grapes grown on his two acres to tourists. (Gora.)

Three

CHAMPAGNE TOASTS ON THE SHORE

Growers east of Cleveland organized Lake Shore Grape and Wine Growers' Association and held a convention in 1866. As early as the 1830s, they showed wines at the Paris Exhibition. Vineyards included Dover Bay Grape Wine Company, Lake View Wine Farm, and Louis Harris Company. The association had 300 members in 1869 and changed its name to the Ohio Grape Growers Association because a temperance movement was taking hold. Those who opposed temperance formed their own group and the pro-temperance branch became part of the Ohio Horticultural Society. The Collamer District became the largest shipping point in the United States in the 1870s, followed by Dover. Glenville and North Collinwood, now in Cleveland's inner city, were covered in vineyards and gardens.

Near the Lake Erie Islands, Catawba Wine Company, which would become Mon Ami, was one of many wineries known for the Catawba grape, widely planted west of Cleveland. In the 1800s, winemaking in Sandusky was empowered by the move of Sweet Valley Winery across the lake to the Ohio mainland and the efforts of H.T. Dewey, Duroy & Gaines, M. Hommel, Mantey Brothers, Meier's vineyards, Engels and Krundivig (also known as Krudwig) Winery, and Bay Shore Wine Company. In 1890, Erie County produced 2.5 million gallons of wine, nearly three times what is produced in Ohio today. As many as 16 wineries prospered within a 25-mile radius of Sandusky, and it was the third-largest wine region in the United States. Many of the wines won medals both nationally and internationally.

Further west, near Toledo, Johlin Winery made wine in Oregon. In 1870, Lenk Winery turned out 400,000 gallons at the first wine cellar in Toledo. East of the Sandusky area, Vermilion and Dover (now Westlake) became dominant vineyard areas.

Industrialization affected the Cleveland area wineries first. Increasing population, pollution during the Industrial Revolution, and demand for land for homes, businesses, and highways reduced grape production. The 20th century brought with it a decline in wine consumption. But, as Lee Klingshirn would say, happy, friendly people carried on.

Preyer House is the oldest structure in Cleveland Heights. Built around 1825, the home was originally associated with John Peter Preyer's Lake View Wine Farm and Vineyard, established in 1864. The stone house was improved by gardens, stables, and a barn. The Preyer farm and vineyards is only one of many in the area that has become a suburb of stately homes. Urbanization strangled the vineyards. (Courtesy of the Heights Community Congress.)

Johlin Century Winery, Bonded Winery Number 69, was established 1870 after Jacob Johlin, who arrived from Germany in the 1840s, cleared land, and planted grapes. The winery once had a 75,000-gallon capacity, and Jacob's son Fred and grandson Richard kept the winery going. The fifth-generation winery remains in the old farmhouse. (Author.)

In 1856, William Henry Mills pressed grapes on his newly acquired Whiskey Run Creek Firelands property. The winery he built on Sandusky Bay became known as Diamond Wine Company. According to the *History of Erie County Ohio,* edited by Lewis Cass Aldrich, Mills produced "an average of 15,000 gallons of wine per year." Patrons went to the Nielson in downtown Sandusky and drank Mills's after-the-theater Sans Pareil Quince wine. (Frohman.)

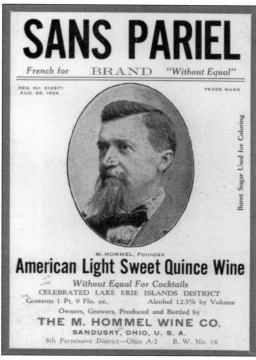

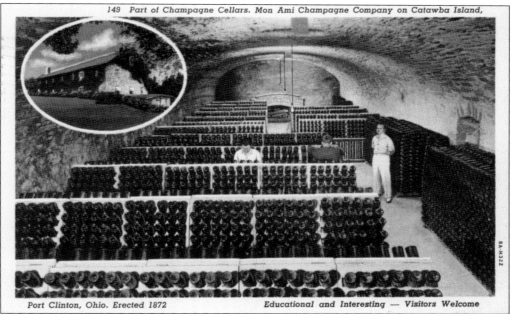

The Catawba Island Wine Company was founded by the Nealses, the Landys, and the Ellithorpes in 1872, and the winery was constructed in 1873. They ran the 130,000-gallon facility until 1937, when the property was purchased by Mon Ami Champagne Company of Sandusky. Mon Ami once employed 55 men and produced 500,000 bottles of champagne, burgundy, and other still wines. Restaurant facilities were added in 1945 following a fire that gutted the interior. (Frohman.)

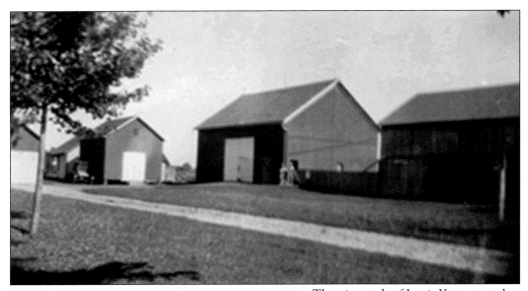

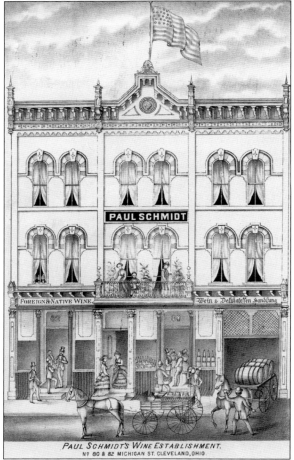

PAUL SCHMIDT

FOREIGN & NATIVE WINE. Wein & Delikatessen Handlung

PAUL SCHMIDT'S WINE ESTABLISHMENT.
Nº 80 & 82 MICHIGAN ST. CLEVELAND, OHIO.

The vineyards of Louis Kratzert and A. Heinsohn of Dover, in current Westlake, were high producers in the late 1800s. In the early 1930s, grape farmers in Avon, Dover, and Vermilion formed a grape co-op. Grapes were picked by hand. The region was devoted more and more to table wines and was dominated by the Concord grape. Leonard Alber tended his vineyards throughout the 1970s. (Esther Albers' Collection, courtesy of Westlake Porter Public Library.)

This 1874 print from a wood engraving portrays Paul Schmidt's Wine Establishment at No. 80–82 Michigan Street, Cleveland. The proprietor sold both foreign and native wines during Cleveland's period of rising industry, when another wave of immigrants was arriving in the city. (Courtesy of Cleveland Memory, Cleveland State University [Memory].)

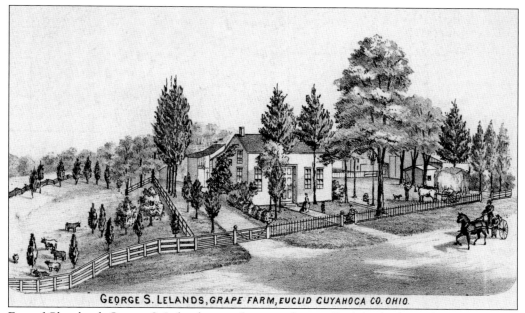

GEORGE S. LELANDS, *GRAPE FARM, EUCLID CUYAHOGA CO. OHIO.*

East of Cleveland, George S. Lelands owned a grape farm in Euclid, which was being developed at about the same pace as Westlake, west of Cleveland, with farmland slowly giving way to homes and commercial ventures. This wood engraving shows the grape farm with outbuildings and livestock. The 1874 print is from the *Atlas of Cuyahoga County, Ohio.* (Memory.)

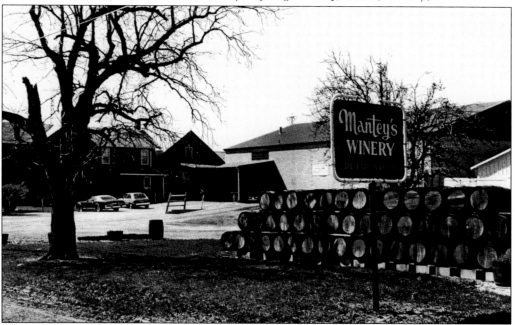

In 1880, Edward Mantey, originally from Kelley's Island, purchased land in Venice, west of Sandusky. Much of his fruit farm was allotted to grapes. Mantey's wine was eventually sold from Pittsburgh to Chicago. His two sons joined their father's business, which grew to over 50,000 gallons of wine a year. (Courtesy of Firelands Winery [Firelands].)

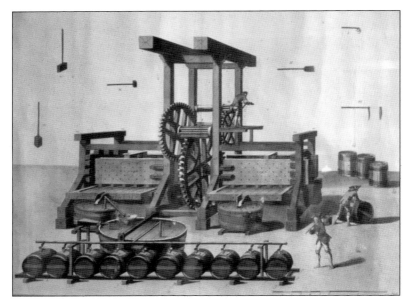

On the walls of present-day Firelands Winery, formerly Mantey Vineyards, is this picture of a French machine that assisted with wine production. Mantey produced fine Ohio wine, now crafted through Firelands Winery. (Author, courtesy of Firelands.)

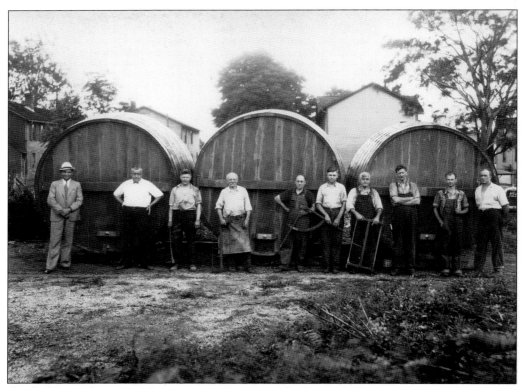

Sandusky was the center of important cooperage works that specialized in supplying the wineries with what they needed to make their products. The firm of Klotz & Kremer made crushers, presses, and pumps, and Schwab Cooperage, also of Sandusky, made the casks shown in this 1934 photograph. (Frohman.)

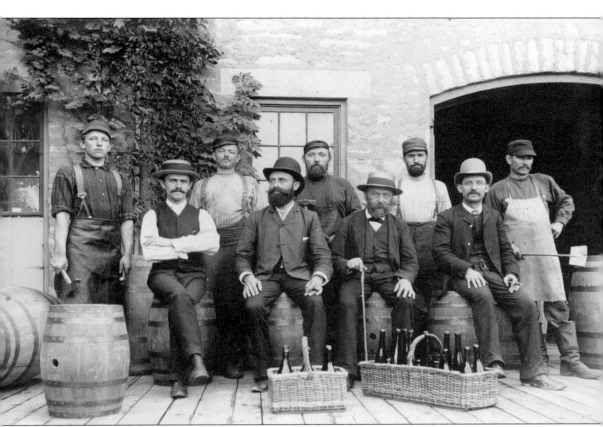

Jacob Engels moved from wine importation to viticulture when he planted a 10-acre plot of grapes east of Sandusky in 1860. He erected a winery in 1863. R.P. Krudivig joined the Engels family, and they became the leaders in the burgeoning industry. In this 1890 photograph, Engels and Krundivig Winery employees are dressed for their roles as merchants, cultivators, or winemakers. The barrels and baskets were likely made locally; the wine industry helped to keep people employed. (Courtesy of the Ohio Historical Society.)

Engels and Krudwig on East Water Street, Ohio Bonded Winery No. 5, was famous for Diedesheimer and Laubenheimer. At the turn of the 20th century, E&K native wines were known across the eastern United States. The winery line included sparkling wines and vermouth, and with the erection of the distillation equipment, the business went into grape and fruit brandy production. (Author.)

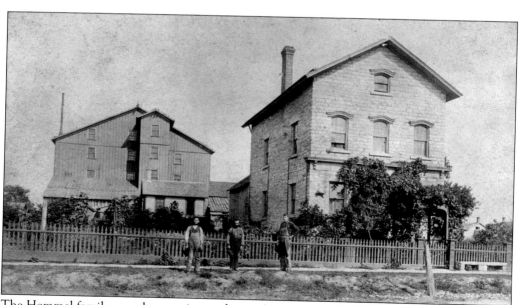

The Hommel family was also a major producer of wine in the Sandusky area. Michel Hommel's winery was founded in 1878 in Sandusky and became Bonded Winery No. 16. Hommel was a Frenchman from the champagne town of Epernay and worked for both Longworth in Cincinnati and Cook in Sandusky prior to starting his own business. (Frohman.)

A late-19th century Hommel catalog lists William Hommel, pictured here with Emily (presumably his wife), as involved in the family business. "Although a specialty of champagne (naturally fermented), we are also a large producer of pure native wines," the catalog states and lists Delaware, Iona, claret, Ives, Malaga, and Tokay wines. It won the grand prize in St. Louis in 1904. Because of Michel Hommel's champagne background, the Hommel Winery specialized in White Star brand sparkling wine. (Frohman.)

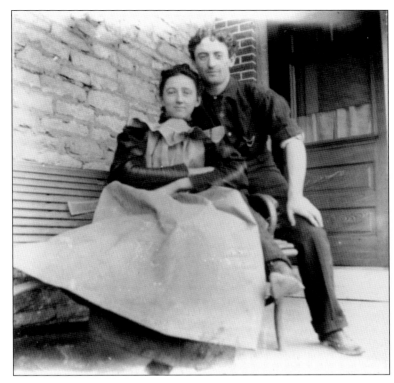

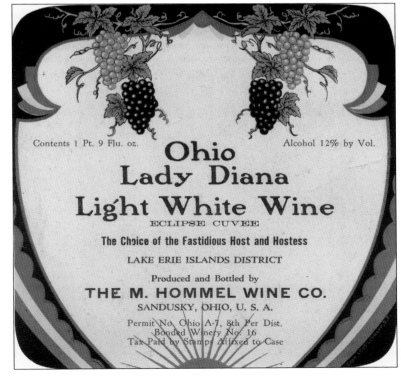

Contents 1 Pt. 9 Flu. oz. Alcohol 12% by Vol.

Ohio Lady Diana Light White Wine
ECLIPSE CUVEE

The Choice of the Fastidious Host and Hostess

LAKE ERIE ISLANDS DISTRICT

Produced and Bottled by
THE M. HOMMEL WINE CO.
SANDUSKY, OHIO, U. S. A.

Permit No. Ohio A-7, 8th Per Dist.
Bonded Winery No. 16
Tax Paid by Stamps Affixed to Case

This label is from Ohio Lady Diana White Wine, "the choice of the fastidious host and hostess." French botanist J. E. Planchon visited wineries in the area in 1873 and remarked that American wine was "superior not only to the frightful brews with which, under the name of wine, the public poisons itself in our cabarets, but superior to our *'petits vins de consommation courante* [table wines].' " (Frohman.)

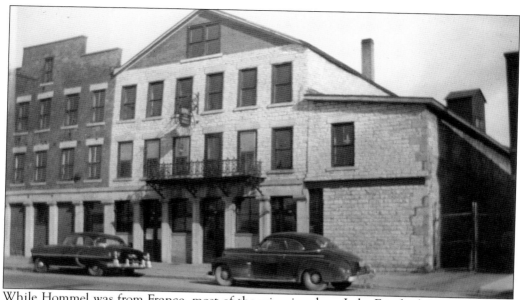

While Hommel was from France, most of the wineries along Lake Erie had German names: Steuk, Engels and Krudwig, Miller, Carl Lenk, and Lonz. The Dorn Winery was founded by John G. Dorn in 1869 with Longworth's original casks. By the time the winery was photographed in 1903, overall grape production was down, but Charles E. Welch began to manufacture and sell unfermented wine. In 1897, Welch's Grape Juice Company pressed 300 tons of Chautauqua County Concords and started purchasing grape juice and grapes throughout the northern Ohio grape region, reducing wine production. It is said that Welch provided juice from the Concord grape, but Dorn, E&K, Meier, Hommel, Lonz, and Heineman provided the wine. In Prohibition survival mode, Dorn's bottling operations in 1931 are in the image below. (Both, Frohman.)

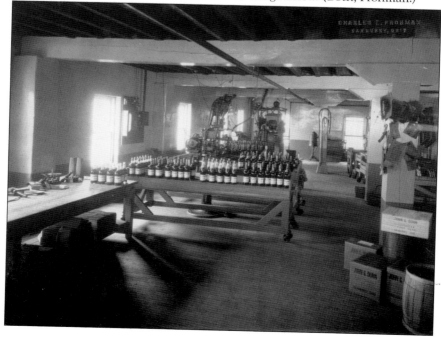

Four

FAMILY FARMS
AND PROHIBITION

Residential and commercial development took wineries from their roots as vineyard growers and wine farms. Concord dominance hindered growing in the early 1900s. With passage of the 18th Amendment and the National Prohibition Act, known as the Volstead Act, in 1919, wineries were forced to close their doors, supply grapes to Welch's, or make juice for consumers.

Wine consumption actually increased during Prohibition. Each household could manufacture up to 200 gallons a year of "non-intoxicating cider and fruit wines." Welch's railcars stopped at the depots along the Lake Erie rail line, and home winemakers met growers to purchase crates of grapes. Bootleggers made wine for speakeasies, and wine was shipped across the lake from Canada to places like The White Oaks in Westlake near Lake Erie's shore. Toward the end of Prohibition, the Fruit Industries delivered "VINE-GLO" grape concentrates to homes and assisted fermentation and bottling, supported by a federal farm-relief program.

Dry table wines outsold sweet wines before Prohibition in the United States. That changed after Prohibition, probably because the wines available during the era were made in home basements using bricks, sometimes called blocks, of wine. To meet the booming demand for grape juice, California grape growers rapidly increased their vineyard areas and sold their juice with a warning: "After dissolving the brick in a gallon of water, do not place the liquid in a jug away in the cupboard for twenty days, because then it would turn into wine." In 1935, after Prohibition ended, 81 percent of California's production was sweet wines, and Ohio followed California's and customers' leads.

Family farms that went back to making wine did so at a high price, because buildings and machinery were out of repair. There was a shortage of experienced workers and winemakers. Some vintners turned wineries into places to have fun and warped American attitudes toward drinking. It was a heartbreaking time for wine enthusiasts, but the area's history as a crop-to-table winemaking hub was preserved at a handful of wineries. Starting in the 1950s, French-American hybrid vines began appearing along the protected shores of Lake Erie.

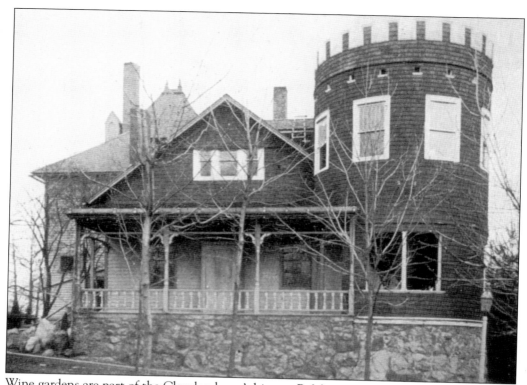

Wine gardens are part of the Cleveland area's history. B. Martinetz arrived from Switzerland in the late 1800s, bought a large vineyard on Lakewood's Madison Avenue, and began to make wine. Customers drove from Cleveland to Martinetz's Wine Gardens to stock up on private wine. After Mrs. Martinetz starting serving lunch, the wine garden became a famous, but non-public, tavern. Vineyards, and wine gardens, disappeared in the early 1900s. (Memory.)

The Ohio Anti-Saloon League was founded in Oberlin in 1893 and contributed to the realization of the Noble Experiment, as Prohibition was called. In 1914, Cleveland's Hammer Company, founded by Alfred Joseph Hammer, started selling sacramental wines bought from Beaulieu Vineyard in Napa. With Prohibition threatening, the Engels and Krudwig families in Sandusky began producing sacramental wines, de-alcoholized wines, and fresh grape juice. The Engels and Krudwig Winery operated from 1863 to 1959. (Author.)

In 1902, Judith Orkin Rosenthal's family settled in Unionville on a 200-acre farm used by Ohio State University's Department of Agriculture, which monitored grape prices. Norman Cohadas of Cohadas Brothers Produce Company of Geneva purchased Highland Farms from Rosenthal's maternal grandparents and grew grapes. This was the history of the area when Anton Debevc established his grape farm in 1916 after immigrating to the area two years earlier from what was later known as Yugoslavia. His son Tony grew up on the grape farm, an introduction to the winery business he would start after he married Rose Marie Petrovic and bought 90 acres adjacent to his father's property. Debevc grapes were Concord and sold to Fischer-Speigel and later to Smuckers. Tony Debevc was a founding member of the Tri-County Grape Growers Association. This picture shows workers in Debevc vineyards. (Courtesy of Debevc family [Debevc].)

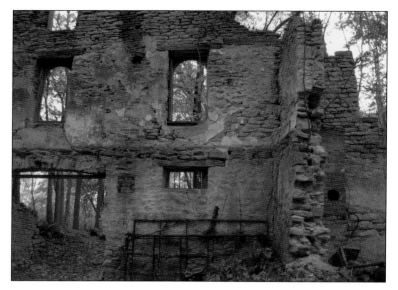

An unfermented grape juice called Rex Champ was made during Prohibition for sacramental and medicinal uses, which helped the Monarch Winery survive. After Prohibition, regular winemaking operations were resumed, and the business continued Kelley's Island's winemaking tradition. The Monarch Wine Company ceased operations around 1950. (Author.)

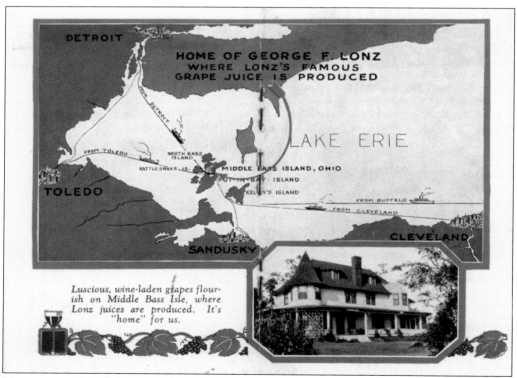

Most wineries handed out tiny booklets as souvenirs and an introduction to the winery, such as this booklet of Lonz Winery, which shows the Lonz home as well. (Frohman.)

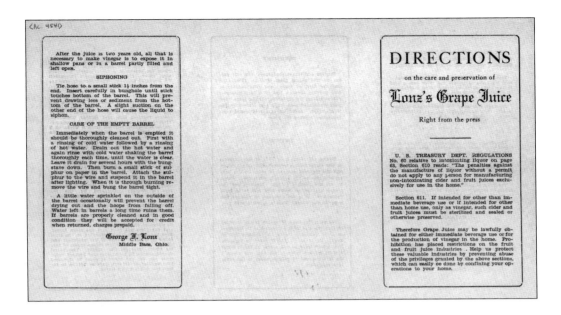

Lonz Winery on Middle Bass Island continued to bottle juice during Prohibition, and like many others, the winery gave customers a brochure warning about fermentation. The brochure cited US Treasury regulations that stated juice can lawfully be used for grape juice or production of vinegar: "You can prevent fermentation by bottling the juice and pasteurizing it in the bottles." (Both, Frohman.)

Crystal Cave was discovered by Heineman Winery workers while digging a well for the winery in 1897. Celestite crystals, ranging from 8 to 18 inches long, cover the walls of the cave. During Prohibition, the Heineman family, under the direction of Norman Heineman, ran tours of the cave, and the winery remained open while others closed. Wine production became juice production, and grape juice was transported by ferry to Sandusky. (Author.)

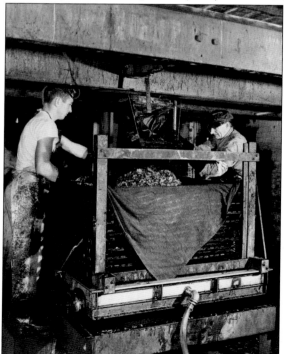

Mantey and Engels and Krudwig were among the first Ohio wineries to apply for a wine producer's permit when Prohibition ended. Packaging methods changed from filling barrels or the buyer's jug to packaging the wines exclusively in glass. Instead of selling to the consumer, the wines were sold to a distributor or retailer. Meier's Wine Cellars Inc., pictured here, operated in Sandusky before relocating to Cincinnati. (Memory.)

In 1934, Engels and Krudwig expanded an additional 18,000 feet and became one of the largest wineries east of the Mississippi; storage capacity was 868,000 gallons. E&K Winery's 1944 display included Haute Sauterne, Ohio Claret, American Muscatel, and Ohio Rhine Wine. Notice the fashionable shoes displayed with the bottles. (Frohman).

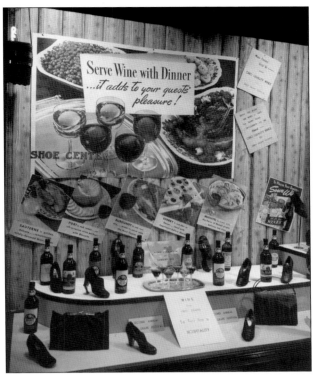

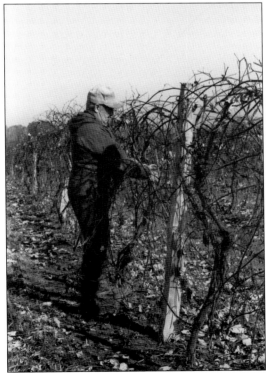

Albert R. Klingshirn began operating Klingshirn Winery in Avon Lake in 1935, but the vineyards are older. Until 1955, Klingshirn produced wine in 20 fifty-gallon wooden barrels in his cellar. The grapes originally produced wine for the family, but large grape crops caused Albert to start selling his wine commercially and build a two-level winery in 1940. (Klingshirn.)

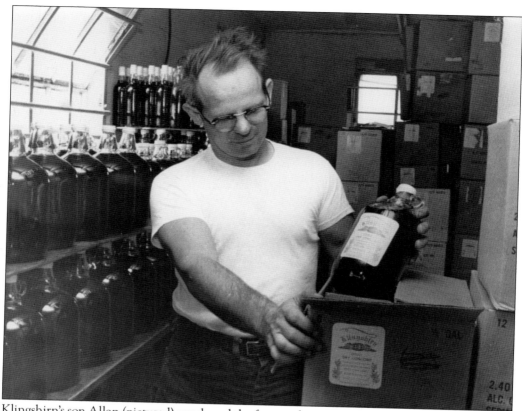

Klingshirn's son Allan (pictured) purchased the farm and winery in 1955. He moved fermentation from small casks to larger wooden casks and stainless steel tanks. In 1978, the business expanded to four times its original size. Allan's son Lee Klingshirn describes his work on the expansion in the foreword to this book. (Klingshirn.)

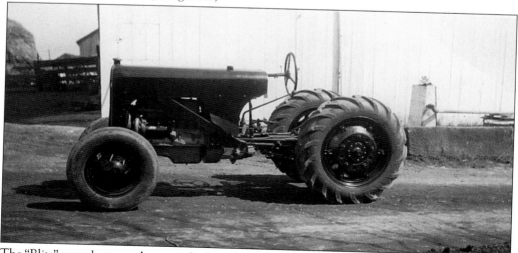

The "Blitz" was a homemade tractor built in the early 1940s for use by the Klingshirn family. Much work at a winery is done by hand—trimming, re-tying, leaf thinning—but the tractors help with removal of brush, fertilization, spraying, cultivation, mowing, and harvest. (Klingshirn.)

The first mechanical harvester at Klingshirn made work easier on the family wine farm. Improvements allowed wineries to produce more product. Mechanical harvesters were introduced by Cornell scientists in the late 1950s and early 1960s. (Klingshirn.)

One of the Welch's depots was just east of Route 83 in Avon Lake where the Avon Lake Feed Mill is today. Many of the growers sold their Concord and Niagara grapes at the depot. This photograph of the depot was taken after nearby Dover Vineyards and the Avon Lake Klingshirn and John Christ Wineries had been established. (Klingshirn.)

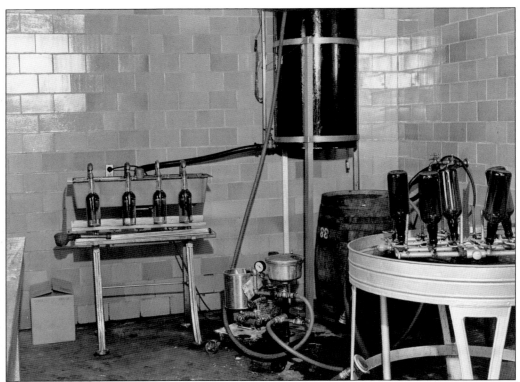

Hungarian Zolton Wolfovitz set up his winery and seafood restaurant on Detroit Road in Westlake in 1934. Dover Vineyards was established on western Cuyahoga farmland and became one of Cleveland's largest wineries. This photograph was taken by Robert Neal. (Courtesy of Cleveland Press Collection, Cleveland Public Library [CPL].)

Dover Vineyards taught customers how to make their own wine and beer at home, a popular pastime. In fact, the February 4, 1941, *Sandusky Register* gave pointers about home planting of grapes and advised, "Grapes are the most popular and widely grown of small fruits in backyards and gardens where space does not permit the growing of bramble and true fruits." Vineyards also screened neighbors. (CPL.)

The cask villas of Vermilion attest to its active winemaking. It was 1941, and America was on the go. Cottages and campgrounds were popular, especially along the lakeshore. Route 60 in Vermilion was once shouldered by acres of vineyards, which is apparent by the names of the buildings and shopping centers today. Old vines are still encountered when land is cleared today. (Frohman.)

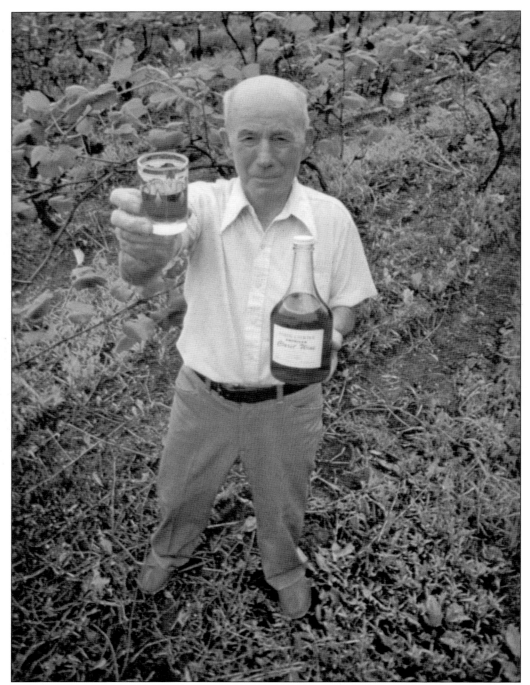

John and Toda Christ, native Macedonians, planted 23 acres of grapes in the 1930s and built a Swiss-style chalet winery in Avon Lake behind the family farmhouse. John Christ Winery sold grapes from the 40-acre farm for grape juice, jams, and jellies starting in 1944. Christ (1902–1986) is shown here in his later years with a jug of wine and offering a glassful of wine. This photograph hangs in the winery today. (Courtesy of John Christ Winery.)

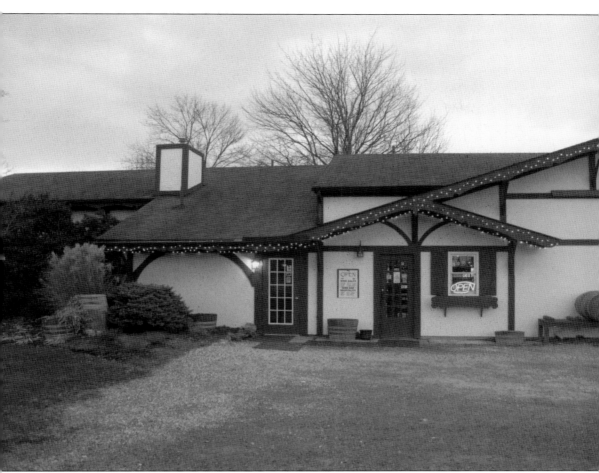

John Christ Winery became a bonded winery in 1946. The grapes on the property were Horwittel, Concord, and Niagara, and the Christs started planting French-American hybrids as well. Others followed course, growing heritage Concord, Niagara, and Catawba grapes as they did prior to Prohibition and trying out some hybrids. The chalet-style building was the winery and winemaking operations were next door. The family home, recently demolished, was nearer Walker Road. (Author.)

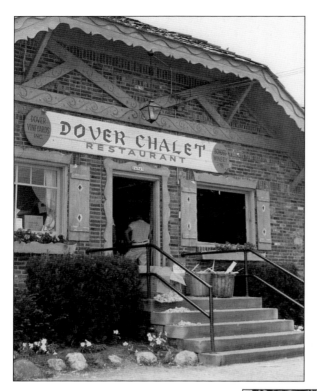

Dover Chalet in Westlake was a rustic winery restaurant with a 100,000-gallon capacity wine cellar beneath the restaurant and winery. It served European specialties like goulash, stuffed cabbage, chicken paprika, and steaks that were served with its wines. The servers wore Hungarian-style white dresses with red vests, and wine bottles lined the walls. These photographs were taken by William A. Vorpe in 1965 after Dover Chalet was bombed. (Both, CPL.)

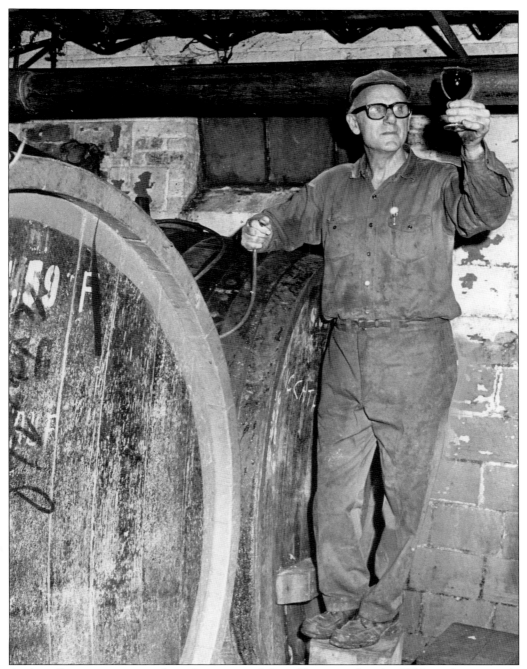

Andrew Somogyi, a winemaker who emigrated from Hungary after the 1956 revolution, made wines under the same roof as Dover Chalet. This image was taken by Herman Seid. Bertrand Sullivan also made wine at a secluded Westlake winery in the late 1950s. The room in which he served patrons was illuminated by one 25-watt bulb and by candles stuck in bottles emptied by customers. (CPL.)

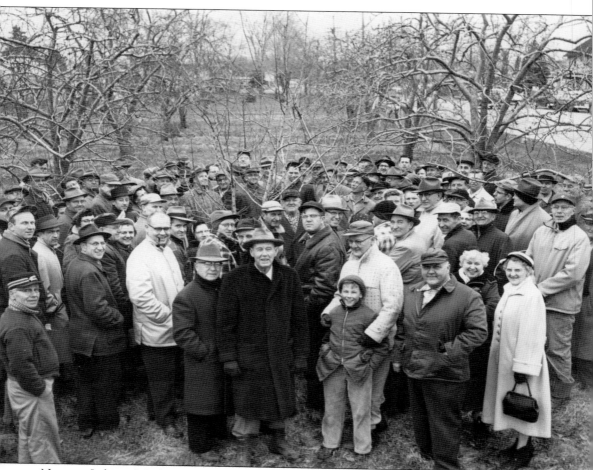

Norman Lehman's Lehman Orchards in Westlake continued into the 1960s. This photograph of a grape-trimming demonstration was taken in 1959 and shows how the community came out in force for an event at the orchards. Lehman was a member of the Greater Cleveland Apple Growers, but he also grew grapes. (Memory.)

Italian-born Nicholas Ferrante made wine in his basement in Cleveland's Collinwood neighborhood before the Ferrante Winery & Ristorante was established in 1937. Nicholas and Anna bought land in Ashtabula County's Harpersfield Township as a country vineyard retreat, which spurred son Peter Ferrante Sr.'s winemaking passion. The Ferrante family was inducted into the OWPA's Hall of Fame. (Courtesy of the OWPA [OWPA].)

Collinwood and Little Italy were heavily Italian, and wine was not only a part of daily life but also part of any celebration. (Memory.)

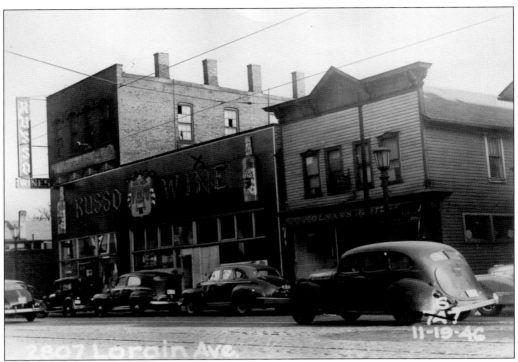

Wine shops and street-front wineries were a natural outgrowth of urbanization. Wine was brought closer to the heart of the city. In 1946, Russo Wine was close to the West Side Market and Cleveland's downtown district, at 2807 Lorain Road. The Bozeglav Winery, at 6010 St. Clair Avenue, was on the other side of the city in 1956. (Both, CPL.)

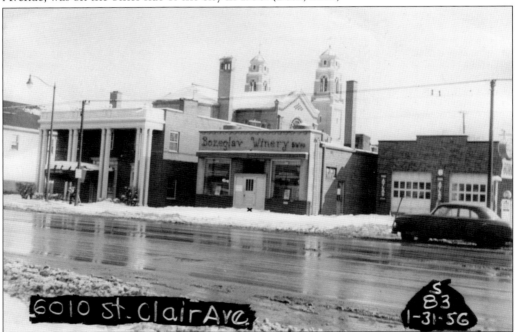

Five

European Viniferas

The late 1960s was a time of great change for Ohio wines. In the far eastern corner of the state, Arnulf Esterer, a former Navy officer and industrial engineer, quietly planted his first European-style grapes at Markko Vineyard, founded in 1968. Esterer perfected his growing methods and enology after studying with Dr. Konstantin Frank of the Finger Lakes region of New York. Not long after, Robert Gottesman, co-owner of Paramount Distillers, Inc., planted some of Ohio's first vinifera grapes on North Bass. Both men inspired others to grow vinifera grapes and were founding members of the OWPA.

In response to demand, the Ohio State Legislature adopted a tax-supported plan to assist viticulture, including a long-range program of Ohio State University (OSU) research. Dr. James Gallander, a professor at Ohio Agricultural Research Development Center (OARDC) in Wooster and a resident at the University of California, Davis, in enology, began to study winemaking in Ohio and promoted Ohio as a progressive competitor in the wine industry. He devoted his time to mentoring new enologists in the fundamentals of winemaking. The other professor who made huge contributions to the Ohio winemaking industry is Dr. Garth Cahoon, who also worked at the OARDC and influenced winemakers to grow better grapes and make better wine.

In 1967, sales of table wines passed those of fortified wines for the first time since Prohibition; Americans were looking for good table wines. The system of American Viticultural Areas (AVA) was established to identify origins of wines. An AVA guarantees that a minimum of 85 percent of the wine in the bottle comes from grapes grown in that AVA. If an individual vineyard's name is on the bottle, 95 percent of the wine must come from grapes grown in that vineyard and from within a recognized AVA. The Lake Erie AVA includes land on the south shore of Lake Erie in Ohio, New York, and Pennsylvania.

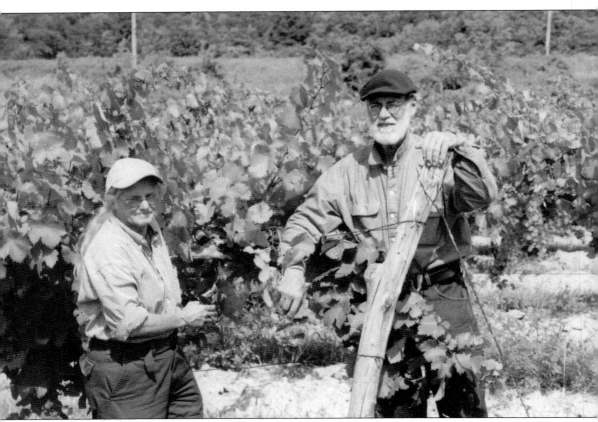

The phenomenon that began in New York's Finger Lakes region traveled to Ohio in the form of Arnulf "Arnie" Esterer, who worked with Dr. Konstantin Frank of Keuka Lake. Frank started producing vinifera grapes in 1962. Esterer, with partner Tim Hubbard, founded Markko Vineyard in Conneaut and started experimenting with Ohio's first vinifera grapes in 1968. Esterer and vineyard manager Linda Frisbie have been working together in the fields and cellars for many years. Frisbie usually hosts in the tasting room, along with Markko dogs. (Courtesy of Markko Vineyard [Markko].)

Arnie Esterer initially planted Chambourcin, Vidal Blanc, and Seyval on 14 acres of vineyards. Esterer works hard on the three marriages that an enologist must make: "Soil with rootstalk, rootstalk with scion, and scion with climate." The rustic winery sits in the woods away from the vineyards. (Author.)

The key to winemaking is to intercept sunlight, achieve air movement so mold cannot grow, and raise the vines five feet off the ground where it is warmer. The grower uses organic fertilizers and builds a wall of leaves so the vines look for the sun. Markko wines ferment in a Burgundian environment. (Photograph by Paul S. Taller [Taller].)

In 1997, Esterer won the Award of Merit, the American Wine Society's highest honor, and the plaque hangs on a tasting-room wall. This simple wooden plaque that sits on a winery shelf highlights Esterer's European ancestry and his commitment to the wines above all else. He is uncompromising when it comes to quality. (Taller.)

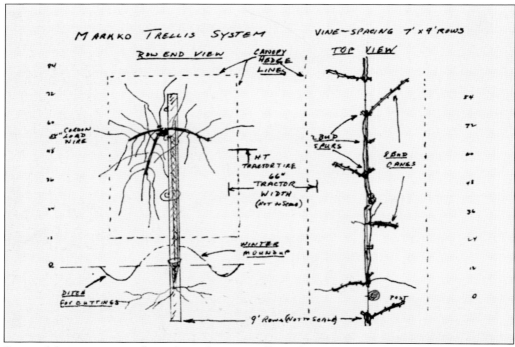

Successful grape growing depends on the vine trellis. When cane tying became costly during the severe winters of 1975 to 1985, Esterer turned to Rene Romberger of the OARDC in Wooster for help. The result was the Markko Trellis System, which raised the bilateral cordon to 54 inches. It is artistically rendered here. (Markko.)

In 1973, in Geneva, the grape growers were Debonne and Morris Cohodas, who had 50 acres of Concord and then Catawba. Rose and Tony Debevc's son Anthony Paul came home from Ohio State University under the influence of wine enthusiasts Roy Kottman and Garth Cahoon, who convinced him to start a winery. So Tony Sr. and Rose mortgaged the farm and lent a hand. (Debevc.)

The name De Bonne means "goodness" in Slovenian. Anthony P. "Tony" Debevc believes in a winery experience that includes music and food. Tony's mother, Rose, and wife, Beth, were among the crew when Chalet Debonne Vineyards opened in Madison in 1971. (Debevc.)

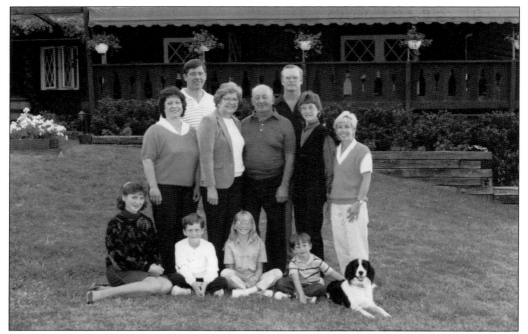

Tony and his wife, Beth, manage the winery business, while the senior Tony manages the vineyards and Rose manages the books. Vineyards expanded and Chalet Debonne's building grew from a small A-frame built from Tony's drawing to a group of hospitality rooms, wine cellars, tasting rooms, juice buildings, and banquet rooms. The wines are award winning. (Debevc.)

The Debevc family also owns an interest in Grand River Sellers in Geneva, which was established in 1976 as Claire's Grand River Cellars. The winery grows quality vinifera grapes in what is now the Grand River Valley sub-appellation of the Lake Erie AVA. Grand River was purchased by Madison Wine Cellars, Inc., which is made up of well-established partners in the wine industry. (Taller.)

Buccia Vineyard in Conneaut was established by Fred and Joanna Bucci in 1975. In 1975, Fred started to attend Ohio State University winemaking conferences, and they bought a six-acre beef cattle farm with pastureland. The original 4.5 acres of vineyard were planted with 1,000 vines of Baco, Seyval Blanc, Steuben, Vignoles, and Agawam grapes. Fred is pictured beneath an awning and working hard; he is good company in the tasting room. (Both, courtesy of the Bucci family [Bucci].)

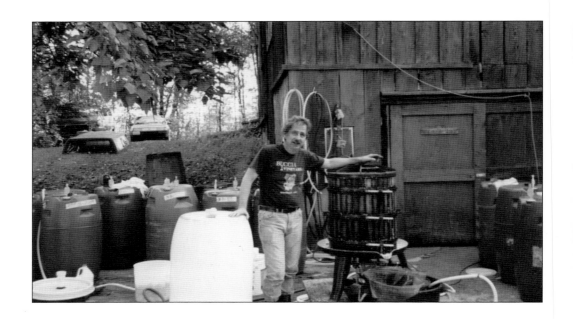

Fred Bucci hand harvests, crushes, and presses in a bladder press. The Buccis' most popular wine has always been their Agawam, and their Baco is fruity and dry. Bucci was a home winemaker who spent time at Markko Vineyard before getting stuck in a traffic jam on the way home from Cleveland and deciding he needed a lifestyle change. That spurred the opening of the winery. (Both, Bucci.)

Harpersfield Winery was established in Harpersfield in 1979 in the heart of the Grand River Valley on land that was the Gerlosky fruit farm. The two-story chateau was built in the middle of the vineyards. Wes Gerlosky planted Chardonnay and Riesling and sold the grapes. He made wine at home until 1985, when he constructed the winery. Gerlosky's interests were eventually sold to area wine-lovers Patricia and Adolf Ribic and Joe and Tony Logan. Gerlosky concentrates on making fine wines. (Both, Taller).

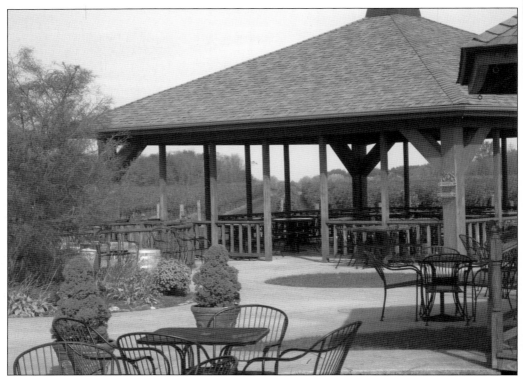

Peter and Anthony Ferrante opened the wood-and-stone winery and restaurant in Ashtabula County's Harpersfield Township in 1979. At that time, they made Russo, Bianco, Concord, and Niagara wines and served pizza. In 1989, it became a full-service Italian restaurant with an Old World feel, but the building was destroyed by fire in 1994. The Ferrantes constructed a new winery building over the original cellar, which was saved, and the business thrived as they added a gift shop and other upgrades. (Both, Taller.)

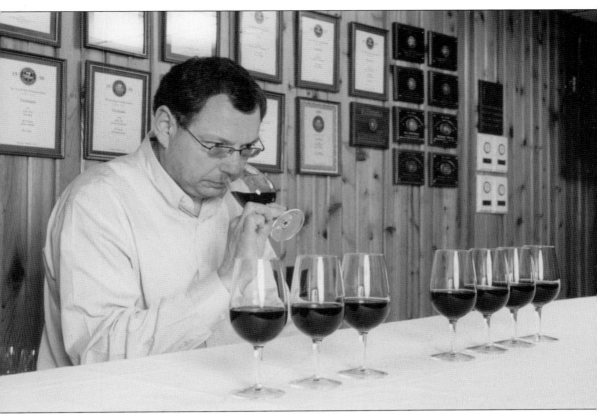

While the wine industry was becoming reestablished in the clay soils east of Cleveland, Mantey Winery in Sandusky was run by Norm and Paul Mantey, grandsons of founder Edward Mantey. In 1979, Robert Gottesman, owner of Paramount Distillers, bought Mantey and Mon Ami wineries and 75 acres of vinifera grapes on North Bass Island. With the addition of Italian winemaker Claudio Salvador in 1984, area wines steadily improved. Firelands has won many wine competitions, both nationally and internationally. (Firelands.)

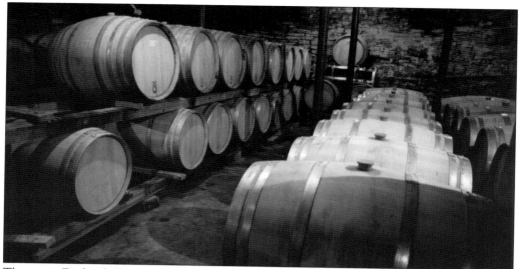

The name Firelands Winery was derived from the historical arrival of homesteaders during the Revolutionary War after their homes were burned. The original wine cellar at Firelands, built in 1880 by the Edward Mantey family, has been incorporated into the present Sandusky facility. The winery continues the Mantey native American wines and planted Catawba and Concord with the vitis vinifera on North Bass Island. (Firelands.)

The Firelands label is used on the vinifera wines from grapes grown on North Bass Island, the smallest sub-appellation in Ohio. By the late 1980s, Cabernet Sauvignon and Chardonnay were grown, followed by Pinot Grigio, Riesling, Gewürztraminer, Chardonnay, Chenin Blanc, and Pinot Noir. Dolcetto was planted at Firelands on the mainland because of its early ripening and ability to sustain cold weather. (Author.)

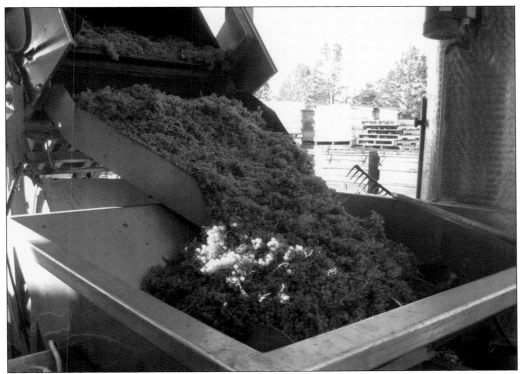

By the 1970s, Lee Klingshirn was running the family wine farm. Klingshirn's vineyards became lush and hearty, as Lee continued his father's and grandfather's visions of a small family winery selling high-quality bottles for carryout and juice for winemaking. In an effort to recognize those wineries that grew their own grapes and made estate wines, the Klingshirn Winery, Markko Vineyard, and Buccia Vineyard were among the wineries that adopted the Lake Erie Quality Assurance label for their products in the 1980s. Tarsitano Winery and Laleure Vineyards would later join the Lake Erie Quality Wine Alliance. (Both, author.)

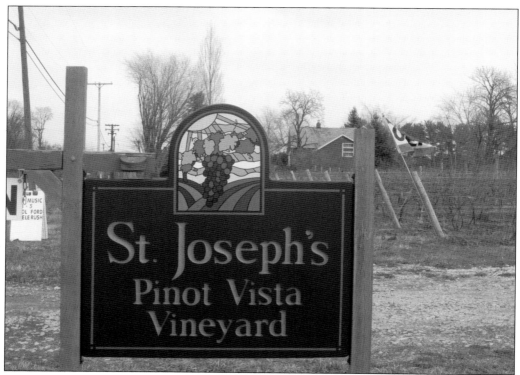

The St. Joseph Winery has its roots as a family farm dating back to 1972. In 1982, Art and Doreen Pietrzyk invested in the Grand River Winery and consulted with Ohio State University, Arnie Esterer, and Presque Isle Winery to come up with some great Pinot Noirs. They purchased farmland in 1986, and the winery named after their son opened in 1987. The Pietrzyks have a Pekin Road vineyard with 50 percent French hybrids and 50 percent vitis vinifera. The winery makes award-winning Pinot Noirs. (Both, Taller.)

Six

CLAY-SOIL VINEYARDS OF THE EAST

The vineyards east of the Cuyahoga are hearty, and beginning in the 1980s, their reputation as fine wine producers became greater than the vineyards to the west and on the islands. The east became the center of the Lake Erie wine industry, because wineries were exploring vitis vinifera grapes and wines, and the Debevcs and Ferrantes started distributing their wines across the area.

The wineries appear in this section of the book in the order in which they arrived on the scene after the adventurers of the 1960s showed them the way. The next of the existing wineries to open its doors was the Old Firehouse Winery in 1988. Between 1988 and 2000, fourteen more wineries opened along Ohio's eastern shore, more than one a year. A short history of each appears here, and most of them are in chapter eight as well, where the wineries as they are now are "toured" in the pages of the book.

The passion that planted the ideas came from the pioneers of European-style grapes in the 1960s and 1970s. Geneva-on-the-Lake's tourism industry's close proximity to vineyards propelled people to explore the wineries in the area. The Lodge at Geneva State Park promotes the wineries with tastings and weekend winery packages. And in the vineyards and wine cellars, grape growers and winemakers continue their work while friendly, happy people wander by.

Donniella Winchell of the OWPA grew up amongst Concord grapes in Madison and was asked to become the executive secretary of the organization in 1978. Robert Gotttesman was a key organizer of the group. Thirteen wineries approved a budget of $700 and limited Winchell's hours to six a month to reserve enough money to purchase postage stamps. The OWPA, located in Geneva, has been instrumental in assisting viticulturists and enologists along the lakeshore and on the islands. (OWPA.)

The Old Firehouse Winery opened in Geneva-on-the-Lake's first fire station. This summertime resort was founded in 1869. Old Betsy, a 1924 Graham Brothers fire truck, sits in front of the firehouse, and a historic Ferris wheel stands behind. The Old Firehouse joined the strip's eclectic mix of amusements, shops, and eateries in 1988. Old Firehouse Winery's winemaking operation is overseen by vintner Don "Woody" Woodward, with cellar master Drew Raymond providing the ongoing processes. The winery uses grapes from the Lake Erie growing region, mostly from the Grand River Valley. Twenty wines are available, ranging from a dry Chardonnay to a sweet Riesling and everything in between. Best-sellers include the traditional labrusca-based wines: Firehouse Red, Pink Catawba, and Grape Jamboree. The #5 Big Eli Port wine features the Ferris wheel on the label. (Above, courtesy of Firehouse Winery; below, Taller.)

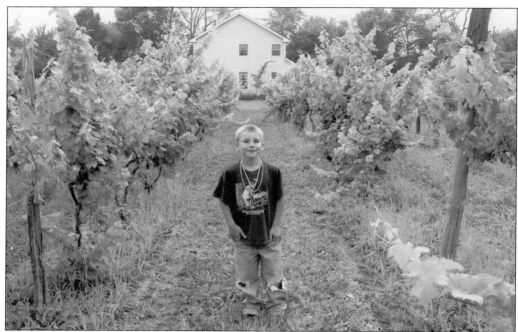

Patty and Jim Iubelt bought an old family farm in 1994 and founded Maple Ridge Vineyard in Madison. Patty had been experimenting with enology for years prior to opening the winery. Jim has a farming heritage, worked in the wine business, and traveled a lot, which influenced the Old World style of the vineyards and winery. The Iubelts planted four acres of grapes—Chardonnay, Cabernet Franc, Pinot Noir, Gewürztraminer, Riesling, and Pinot Gris—and discovered the site does not get frost like other locations. The winery uses medium toast French barrels that are not redone (shaved on the inside) and last for years. They do the pruning themselves, but volunteers and a few Amish employees help. With Fred Bucci's help with the paperwork, this cozy winery is Ohio Bonded Winery No. 80. The Iubelts' son photographed in the vineyards is now 16 as of 2011. (Above, courtesy of Maple Ridge; below, Taller.)

Laleure Vineyards was established in Parkman in 1997 by Rich and Betsy Hill. The winery is on a former dairy farm. The newer barn was built in 1953 and the old one in the mid-1800s. The house was constructed in 1867. The Hills purchased the property in 1996 and started digging 250 holes by hand for posts. The initial planting was three acres of grapes helped along by the breeze that flows through the Grand River Valley. The winery was named for Rich Hill's grandmother, a war bride from France who introduced the concept of drinking wine every day. (Both, Taller.)

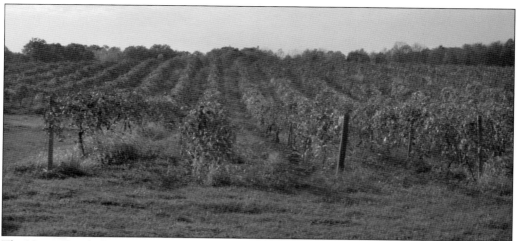

The Virant family farm has been home to five generations, starting with Lewis Virant who moved to the country in the 1930s and began farming. In 1967, Frank and Charles Virant planted an 11-acre vineyard. As with many area wineries, growing grapes led to making wine to sell to the neighbors. The Virants started making their wines in the early 1960s and continue to offer award-winning Chambourcin and Cabernet Franc. The winery opened in 1998, and its vineyards overlook rolling countryside in Geneva. (Taller.)

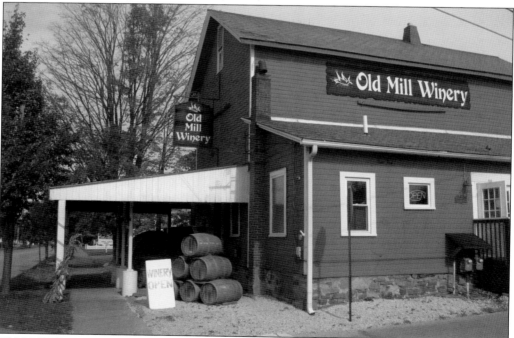

Old Mill Winery & Restaurant was opened in recent years near the railroad on the road that leads to Geneva-on-the-Lake's strip. It serves European-style wines, including Chardonnay, Riesling, and Cabernet Sauvignon and French-American Cabernet Franc and Chambourcin, as well as native wines. The winery experiments with native grapes, producing a Grindstone Red similar to Lambrusco and Grindstone White made from Niagara but styled like a French Sauterne. (Taller.)

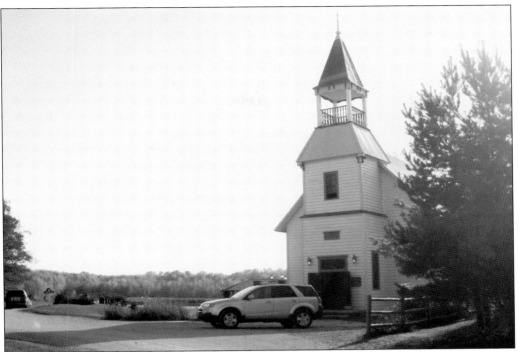

Gene and Heather Sigel of South River Vineyards met while employed at Chalet Debonne and leased a small two-acre vineyard in 1995 before purchasing their present estate in 1998. In a unique move, they dismantled and moved an 1892 Victorian chapel nail by nail from its Portage County home. In 2000, the pieces of the building were marked prior to transporting it 50 miles to 32 acres in Harpersfield Township. The farm's old Concord vineyards were bulldozed and replaced by Riesling, Chardonnay, Cabernet, Merlot, Pinot Grigio, and Syrah vineyards. (Both, Taller.)

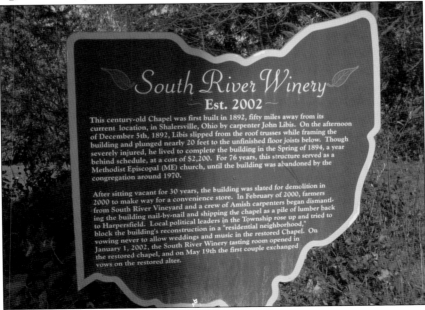

South River Winery
Est. 2002

This century-old Chapel was first built in 1892, fifty miles away from its current location, in Shalersville, Ohio by carpenter John Libis. On the afternoon of December 5th, 1892, Libis slipped from the roof trusses while framing the building and plunged nearly 20 feet to the unfinished floor joists below. Though severely injured, he lived to complete the building in the Spring of 1894, a year behind schedule, at a cost of $2,200. For 76 years, this structure served as a Methodist Episcopal (ME) church, until the building was abandoned by the congregation around 1970.

After sitting vacant for 30 years, the building was slated for demolition in 2000 to make way for a convenience store. In February of 2000, farmers from South River Vineyard and a crew of Amish carpenters began dismantling the building nail-by-nail and shipping the chapel as a pile of lumber back to Harpersfield. Local political leaders in the Township rose up and tried to block the building's reconstruction in a "residential neighborhood," vowing never to allow weddings and music in the restored Chapel. On January 1, 2002, the South River Winery tasting room opened in the restored chapel, and on May 19th the first couple exchanged vows on the restored alter.

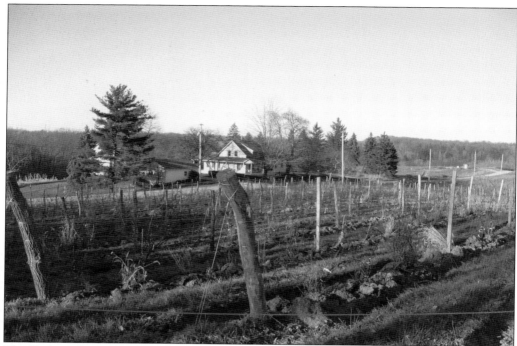

The Tinker's Conneaut farmhouse was built in 1850 and was a stagecoach stop on the turnpike before it became home to the Hatch family. The grain farm became Isaac Aho's dairy farm. In 2001, Kenneth Tarsitano opened Tarsitano Winery on the original of Hatches Corners Road location (building below). Tarsitano learned early winemaking from his grandfather, who was from the Collinwood neighborhood. When Ken left the advertising business, he took a break to photograph China and hike the Appalachian Trail before beginning work as an organic farmer at the OARDC. There, he learned how to grow and care for grapes, with guidance from Fred Bucci, Nick Ferrante, and Joe Biscotti, but mostly from Arnie Esterer at Markko. (Both, Taller.)

Biscotti's Family Winery, in Conneaut, is an outgrowth of Joe Biscotti's work as a Cleveland-area restaurant owner-chef and his Adriatic heritage. He and wife Nancy bought Conneaut Shores golf club and restaurant in 1999 and started making wine in the cellars. Joe's Old Italian Red is a handcrafted Old World Italian. The winery became a Conneaut Creek winery, along with Buccia and Markko, in 2002. Wines are made on the premises with local grapes. (Taller.)

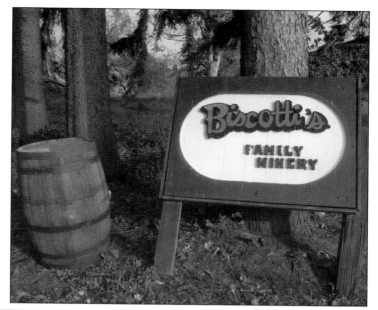

The Lakehouse Inn Winery was established on the shores of Geneva-on-the-Lake in 2002. Karen and Sam Fagnilli envisioned hosting a wine country escape when the area expanded its vineyards. They converted the 1940s Collinger hotel, cottages, and beach house into a bed-and-breakfast and winery. That first year, they purchased finished juice. Sam Fagnilli is a self-taught enologist who buys grapes from the area and augments them with stock from elsewhere. (Taller.)

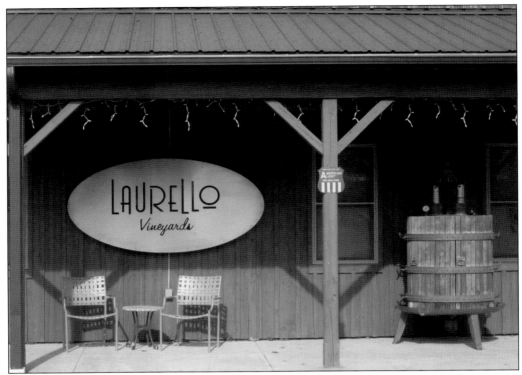

Laurello Vineyards was established in Geneva in 2002. Kim and Larry Laurello bought the 86-acre orchard and vineyards, formerly the Burkholder farm, in the 1990s and renovated it into an Italian Mission-style winery. The barn, where processing takes place, is 100 years old. The Laurellos were inspired by Cosmo Anthony Laurello, who owned and operated a small winery in Ashtabula in the 1940s until wine consumption declined. Grandpa Cosmo is honored by a blend of Merlot and Sangiovese, and Kim's grandmother's love of gardenias is celebrated in Sweet Genevieve ice wine. (Both, Taller.)

Jason Emerine opened Emerine Estates in 2003 in Jefferson. Emerine Estates is a fourth-generation winemaking operation. His grandparents started making wine in 1920s, but Jason started the first official winery the family has owned. It has access to 268 acres of vineyards and fruits and four million bees. The bees produce the yeast for fermentation, and a late-harvest nectar is induced by evaporating the waters and inverting sugar to create wines that are highly concentrated ("up to 127 percent," according to Emerine). Wines are fermented in toasted barrels. A chemistry major who likes to create, Emerine uses all natural methods but is not organic certified. Emerine credits Arnie Esterer with teaching him to be patient and let the wine blossom. (Both, Taller.)

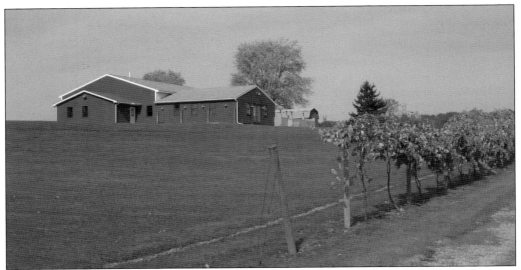

Farinacci Winery, Ltd., in Austinburg, was established in 2006 on 38 acres of farmland named for the Farinaccis of Gildone, Italy, by the Adriatic Sea. Antonio Farinacci settled in Little Italy in 1912 and was a home winemaker. His son Dominic and grandson Michael did the same, and in 2004 Michael and Dawn opened their commercial winery near where Antonio took his grandson Michael to buy grape juice. They converted a barn into a winery with a patio and great room. (Taller.)

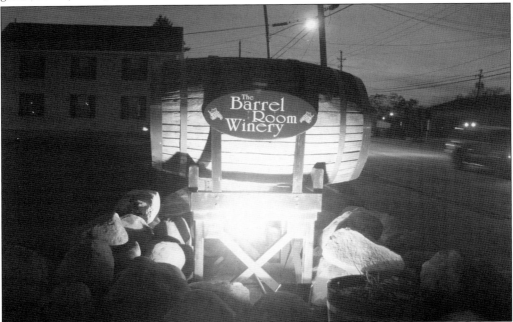

The Barrel Room Winery in Wickliffe opened in 2007 in a small strip mall in the middle of a bustling suburban area. The winery is proud of its Cabernet Sauvignon, Sangiovese, and Merlot wines made from California grapes. One of the owners came to this country at the age of 13 and has been making wine for 30 years. The business provides a Tuscan atmosphere, which includes very detailed stone, granite, and marble craftsmanship. (Taller.)

The Winery at Spring Hill, in Geneva, was established in 2009. Siblings Tom and Cindy Swank owned a historic farm market, but the idea grew for them to open up a winery. They met Jim Pearson and Richard Trice, went into partnership, and changed direction. Although a river-rock facade was installed on the building and a granite-topped wine bar was constructed, the owners tried to maintain the feel of the market. The wine is made on-site from all–Lake Erie grapes. (Taller.)

Benny Buccihas of Bene Vino Urban Winery in Perry Village brings wine close to the population with an "urban" winery. The winemaker has been making product professionally since 2004, but he grew up in a home where they pressed grapes and stored them in the basement. Bene Vino was voted Best of Cleveland in 2010, the first year Buccihas was in business. The wines, most of which are not from Lake Erie Appellation grapes, have been judged exceptionally good. (Taller.)

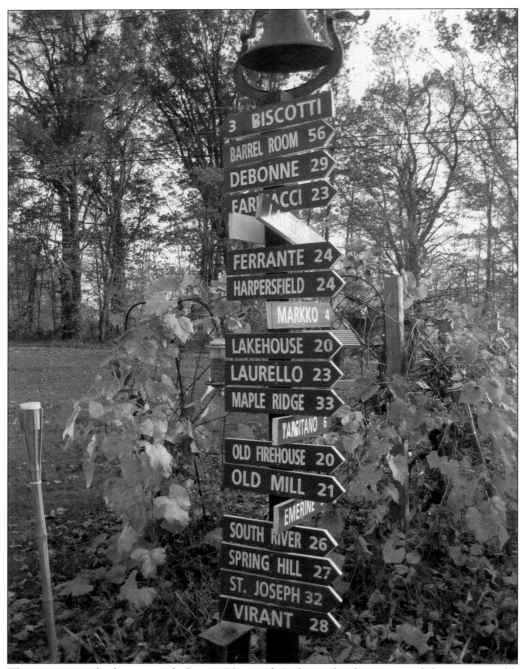

3 BISCOTTI

BARREL ROOM 56

DEBONNE 29

FAR ACCI 23

FERRANTE 24

HARPERSFIELD 24

MARKKO 4

LAKEHOUSE 20

LAURELLO 23

MAPLE RIDGE 33

TARSITANO 6

OLD FIREHOUSE 20

OLD MILL 21

EMERINE

SOUTH RIVER 26

SPRING HILL 27

ST. JOSEPH 32

VIRANT 28

This sign is on the lawn outside Buccia Vineyard. It shows the distances and directions to the surrounding wineries. The marker reminds visitors that there are other wineries not far away. Hosts often provide directions to the next winery down the road, and with roadside signs that point out the wineries as tourist destinations, visitors rarely get lost. A similar sign stands on the strip outside Old Firehouse Winery, but the distances and directions are different because it is a different location.

Seven

Uncorking Potential in the Sandy West

Sadly, with the collapse of Lonz Winery, only one wine-producing winery remains on the islands in 2010—Heineman's on South Bass Island, which grows only a small percentage of its grapes on South Bass. The rest of the grapes used in Heineman's wines have to be imported, mostly by boat from North Bass Island. Isle of St. George, also known as North Bass Island, has become a sub-appellation and continues in full grape production on land leased from the State of Ohio, which is committed to supporting Ohio's wine industry. Firelands Winery, one of the two largest wineries in Ohio, grows many of its grapes on Isle of St. George.

For many years, the known wineries on Ohio's western shores were Firelands in Sandusky, Mon Ami at Catawba, Lonz on Middle Bass, and Heineman's on Put-in-Bay. But some, like Johlin Century Winery in Oregon and Sweet Valley on Kelley's Island, continued making wine. A new Kelley's Island winery opened in the early 1980s, and over the last 10 years a dozen new wineries have opened along the western Lake Erie shore. Impassioned growers and vintners have learned how to grow grapes in the sandy soil and make good wines from grapes with a less intense flavor than those in northeastern Ohio. These folks that are uncorking potential west of the Cuyahoga River are well aware of the area's history.

During the last 30 years, wine has become linked to a healthy lifestyle. While there is a contingent of wine tasters looking to get tipsy from drinking wine, most wine lovers are interested in serving wine with dinner or having a supply for special occasions.

Kelley's Island Wine Co. was established on Kelley's Island in 1983. In the 1970s, the only winery on Kelley's Island was Sweet Valley Wine Company. In 1979, the Kirt and Robby Zettler family purchased 20 acres for commercial vineyards. Kelley's Island Wine Company was reborn and continues as the only winery on the island today. The old Kelley Island Wine Co. plaque behind the bar boasts that it makes "Pure Native Wines" from island grapes. (Author.)

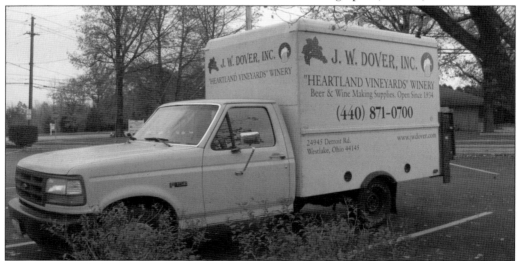

Jerome Welliver grew up in Westlake, not far from the old Dover Vineyards and Chalet. He was making his own wine at home when he bought Dover Vineyards and renamed it J.W. Dover, Inc., in 1997. In 1998, he created the 4,000-gallon Heartland Vineyards Winery. The new business featured table wines like Cabernet and Chenin Blanc, mead, and melomel (fruit and honey wines), and Welliver continues the location's tradition of introducing home brewing and winemaking to the public. (Author.)

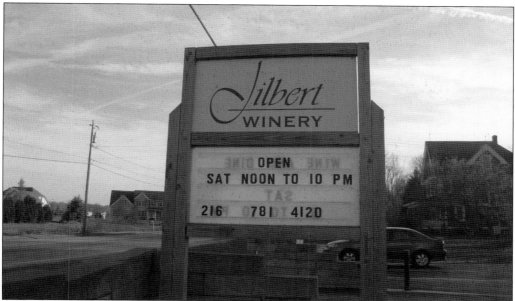

Jilbert Winery was opened in a historic 1905 dairy barn in Valley City in 1999. The property includes the Jilbert house, built in 1913, as well as an apiary. Winemaker David B. Jilbert started out with bees and sought a product for the honey. As a winemaker, he is committed to crafting quality honey (mead) wines, which are unusual in Ohio, as well as grape wines. The winery's grapes are brought in from Avon, but it has established Vidal grapes on the farm in this front-door strategy business that started with making wildflower honey gathered from the owner's property in Medina County. The wines include the Summer Solstice mead, Midsummer Moon honey wine, and Concord, Niagara, and sweet Catawba wines. (Taller.)

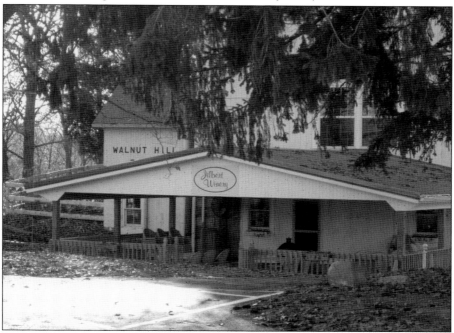

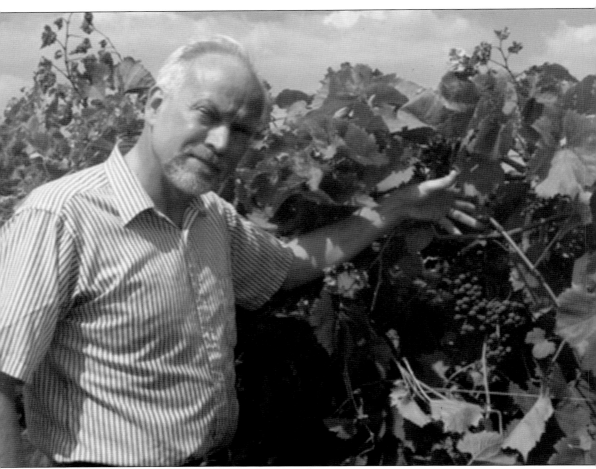

In the northwest corner of Ohio, Stoney Ridge Winery grows Vignoles, LaCresent, Riesling, Cabernet Sauvignon, Marechal Foch, and Blackberry Rage grapes on former vegetable cropland. In 1996, Phillip and Pamela Stotz planted 29 varieties of grapes on property that sits on glacial stones on the ridge of old Lake Erie. At the time, there were no other wineries in the area, and the couple wanted to provide a pastime for local residents in an area where there was not much to do but farm. They named the winery after Stoney Point Schoolhouse and have been serving wine since 2001. In the predominately German territory, their best-selling wines are the sweeter ones. (Courtesy of Stoney Ridge.)

The first vineyards were planted at Hermes Vineyards & Winery, formerly Sand Hill Vineyard, in 2002. The Sandusky vineyards contain 25 varieties of grapes on 30 acres, all vinifera. The Italian, Spanish, Rhone, and Burgundy grapes were brought in from nurseries after owner Dr. David Kraus studied the clones and ordered the grapes. The grapes include Vignior, Alianco, Nebiola, and many other varieties. Michael Kraus, who has a BS in agronomy from Ohio State University, oversees the vineyards on seventh-generation family farmland. The winery was renamed after the owner's mother's maiden name, and the Hermes family still grows grapes in Germany's Moselle valley. (Above, Taller; at right, courtesy of Hermes Vineyards.)

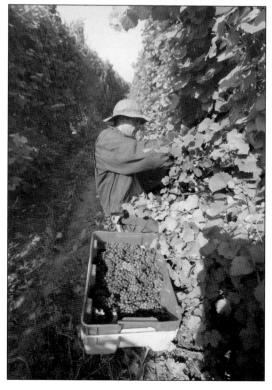

Quarry Hill Winery in Berlin Heights was originally housed in a Quarry Hill Orchards farm market. Enologist Mac McLelland apprenticed with the Christ family of Avon Lake, where he made labrusca wine and introduced vitis vinifera wines. After leaving the John Christ Winery, McLelland planted neat vineyards on the Pinnacle at Quarry Hill, a clearing on the highest point on the farm with a view of Lake Erie and the old stone farmhouse (pictured). It was built in 1835 and mined from the quarries of Quarry Hill. It was recently placed on the National Register of Historic Places. (Courtesy of Mac McLelland [McLelland].)

Single Tree Winery derived its name from the singletree working-horse yoke. The South Amherst winery had its roots in Earl Winder's beekeeping and his winemaking experimentation in his teens. He and wife Sherry teamed up with neighbors Todd and Keri Roby to start a winery in 2004. Single Tree began by growing Bianca grapes from Cornell University and produced mead, fruit, labrusca, and vinifera wines until it closed in 2010. A reopening date is unannounced. (Author.)

Before Mac McLelland had a winery, he hosted wine tastings at a small bar inside the farm market. The photograph above shows the initial planting, while the one at right shows the vineyards fully blossomed. In 2005, McLelland and Quarry Hill Orchards' Bill Gammie built the winery, which has astonishing panoramas from its many windows. McLelland likes to let the wines settle out through racking and filters after fermentation just before bottling and produces fruit and native wines as well as vinifera. (Both, McLelland.)

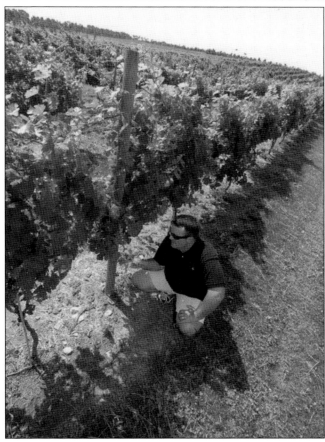

Winemaking began as a basement hobby for Bob Matus. Before he opened Matus Winery, Bob beat seasoned winemakers in competitions. In 1998, he started growing his own grapes, featuring hybrids such as Foche, Chambourcin, Traminette, and Vidal Blanc. In 2003, he was named Northern Ohio Winemaker of the Year. Matus Winery opened on June 17, 2006, on the 75-year-old Matus farm in Wakeman. The building was put together from remnants of an old tavern in Birmingham, wood from trees on the property, and local sandstone. In 2008, the barn was moved, an addition added, and renovations made, shown dramatically in the photographs. (Both, courtesy of Matus Winery [Matus].)

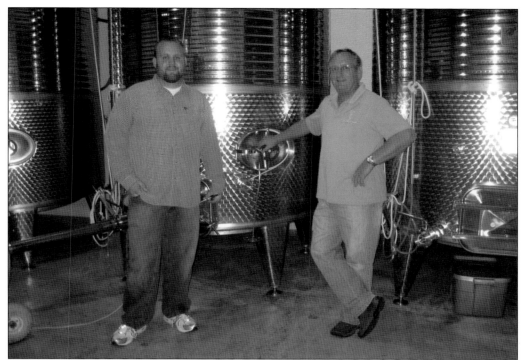

Paper Moon Winery was established on Route 60 in Vermilion in 2008. The winery is owned by Richard and Cheryl Cawrse. Their son Adam, a University of California, Davis, aviation graduate, is a self-trained enologist who read many books and spent lots of time experimenting with wine. Rick owned a 60-year-old dairy in Lorain before running school and senior food services. After the Cawrse family bought the undeveloped land on Route 60, they first had to dig up stumps and clear the growth, including old Concord vines, before planting five acres with Marquette, Chambourcin, Vidal Blanc, and Traminette in an area long ago covered in vineyards. The Cawrses believe in letting the vines mature before picking the grapes, to avoid damage, and will be able to use their own harvest in 2012. (Both, author.)

Mark and Lou Schaublin grew a few grapes on their farm in Gilboa and enjoyed visiting Virginia wineries and winemakers. They decided to grow grapes for area wineries and but had no intention of opening a winery until Mark met Phil and Pam Stotz, owners of Stoney Ridge. Germinated in their conversation, the idea of starting a winery took, and Hillside Winery opened in 2007. (Courtesy of Hillside Winery [Hillside].)

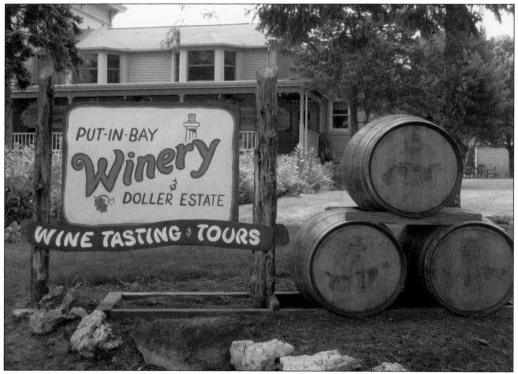

The Doller Estate overlooks the north side of South Bass and is now a museum with a carriage house. The Put-in-Bay Winery at the Doller Estate opened in 2009. The wines are made off-site by a commercial winery from North Bass Island grapes. They can be enjoyed in a remodeled tasting room. Grapes were grown along with other crops by estate owners on the Lake Erie Islands, including the Dollers, who never operated a winery. (Author.)

Vermilion Valley Vineyards opened in Henrietta in 2009 in a partnership consisting of David Benzing, Jack and Fran Baumann, and Larry and Mary Gibson. Grape grower and winemaker David Benzing's ambitious efforts led the owners to plant a variety of grapes, ranging from Pinot Noir to Dornfelder and Gewürztraminer to Traminette, on 23 acres. The winery uses efficient design strategies like trellising, shading, and solar energy, and the vineyards use the pond for irrigation and storm water management. The interior includes ash wood milled from a local site, and double-wall construction saves on heating and cooling. Working in the vineyards, David Benzing is in the foreground and Richard Donahue is in the background. (Both, courtesy of Vermilion Valley Vineyards.)

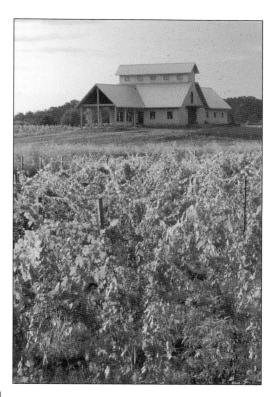

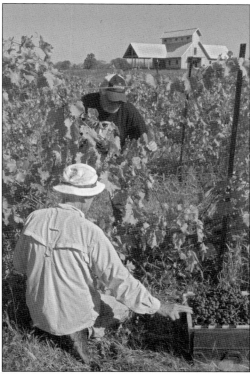

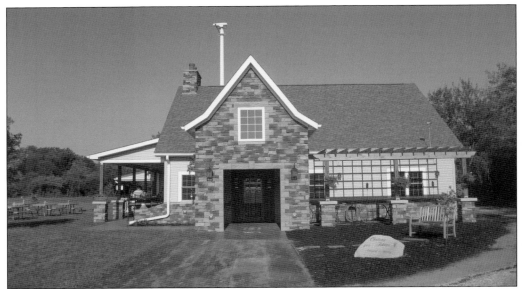

Chateau Tebeau Winery, in Helena, is a new business that is growing its own grapes on the premises. Bob and Mary Tebeau bought the 36-acre farm in 1996 and were not sure what they were going to do with all the land that surrounded the home they built. The couple had raised a family and sought a rural life, and they had been visiting wineries and exploring the lifestyle. They attended classes to learn viticulture and enology and decided to plant Noriet, Traminette, Frontenac, and Pinot Gris grapes in 2008 and have been adding more grapes in the years since, now under the guidance of a vineyard manager. The winery opened in January 2010. (Both, Author.)

D&D Smith Winery was established in Norwalk in 2009 on the weekend after Thanksgiving. Self-taught vintners Denny and Danielle Smith made 500 cases in 2010. The 1870 house they bought was originally across the river and was moved to its present location in the 1930s. The wines are processed and fermented in the cellar, which is immaculate. Danielle explains that the winery buys local grapes as much as it can and supplements with grapes from Argentina and Spain. The wines range from a dry Cabernet Franc to a semisweet Concord to blueberry wine. The old house has been opened up with a tasting room balcony on the top floor. (Both, Taller.)

The stately walls of the original Kelley Island Wine Company compete with the trees in height. Kelley Island Wine Company remained in business until the 18th Amendment made it illegal to sell wine in the United States. Fire destroyed all but the stone walls and vaults. Kelley Island Wine Company produced twice as many gallons as all the other wineries on the island combined—as much as 163,550 gallons as early as 1872. This window looks into the winery and back into history from the present. As visitors tour the wineries existing in 2010, they are constantly reminded of the history of the industry in the Lake Erie region. (Author.)

Eight

LAKE ERIE VINES AND WINES TRAIL TODAY

The OWPA has established wine trails throughout the state of Ohio, which makes it easy for the public to see where the wineries are in relationship to each other and take wine-country excursions, much like visitors do in California and the New York Finger Lakes region. Wine tasters will want to explore the color, the swirl (wine with good "legs" is high in sugar or alcohol), the smell (fruity, oaky, floral, musty, buttery), and then taste the wine. They must be open to the experience of tasting wines that may be sweet labruscas, fruit wines, mead or honey wines, or vinifera wines from the Lake Erie Appellation or grapes brought into the area to make European-style wines. Those who explore the region should remember that wine originates with the grapes and is enhanced by the winemaker.

When visiting Ohio's Lake Erie wineries, one may want to think about the grape berry that grows on a vine, is pressed to extract juice, and is fermented into wine. Harvest season, from mid-August through October, is a good time to visit wineries to get a feel for how the grapes are harvested and become wine. Some wineries handpick grapes while others use machines. Red wine color and tannins come from the skin. The wine can be barrel or bottle aged, and the traditional 60-gallon oak barrel is considered best. The wineries take part in several local events each year, such as the Ashtabula County Covered Bridge Festival, Taste of Ohio Wine Festival, and Tannenbaum Festival, but personal tours are best.

The wineries east of Cleveland on the Vine and Wines Trail are in Lake, Ashtabula, and Geauga Counties. This region includes Conneaut Creek wineries, the region between Conneaut and Geneva, Grand River Valley, Lakeshore wineries, and the Hills and Dales wineries. A mini-tour starts at the eastern edge of the state in Conneaut and travels west toward Cleveland, along the lake and in the countryside, ending in Perry Township. Always, the history of the winery, passion, and hard work tempered with patience are part of the experience.

Just west of Conneaut on the lake road, Biscotti's Family Winery is operated in a century home. The outdoor patio overlooks a golf course. The small gift shop sells hand-painted glasses, wine gadgets, and memorabilia, and Nancy Biscotti presides behind the 1950s-style breakfast bar to serve Old Italian, Merlot, and Tony Soprano Red. The first two are vaguely sweet, blood-warming, hearty wines. The next stop is Buccia, down the road to the south. (Taller.)

Buccia Vineyard's winery and bed-and-breakfast are announced by a blue sign near the road. The winery is entered through a trellised patio, and inside Fred or Joanna is welcoming with bottles of Baco, a berry red. Joanna makes bread for tastings, and the bed-and-breakfast has indoor hot tubs and patios with arbors. The winery started with 1,000 vines in 1975 and has 4,500 today. (Taller.)

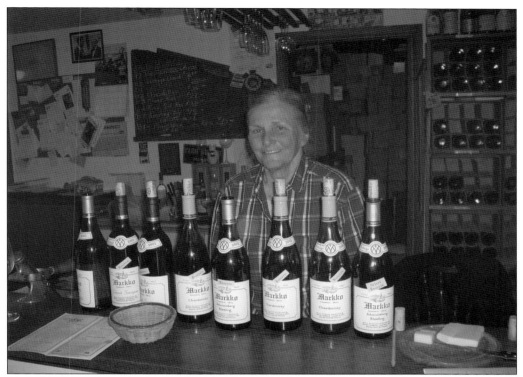

Meander over covered bridges and arrive at Markko Vineyard, previously occupied by a Finnish dairy farm. The outside sign announces that they may be in the vineyards, but winemaker Arnie Esterer and vineyard manager Linda Frisbie, as well as the Markko dogs, are usually in the tasting room. Arnie Esterer is exuberant about his wines and winemaking, and Linda can explain the difference between a 2005 estate-bottled buttery Chardonnay and a 2006. Markko wines have big, bold tastes. (Taller.)

Tarsitano Winery perches on a ridge in a cedar-sided barn not far from Esterer's place. Ken Tarsitano believes that the wine and the food he serves are an "expression of the land and the area." The winery is certified organic and makes 12 varieties of wine from Auxerrios to Pinot Noir from grapes grown on 17 acres of vineyards. (Taller.)

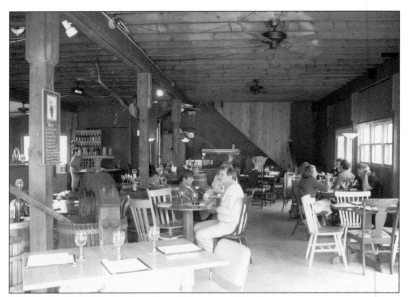

Ken Tarsitano bakes round loaves of bread and talks to wine tasters while he works. The winery is known as much for its food as its wine. (Taller.)

Emerine Estates in Jefferson sells only 100-percent, all-natural, handcrafted, and chemical- and preservative-free wines and uses no machines for winemaking, no sugars, no artificial flavors or colors, and no filtration. Owner and winemaker Jason Emerine uses grapes from family vineyards, specializes in fruit wines, and sells food to enjoy with the wine. He is passionate about his winemaking process and provides a chemistry lesson during tastings. Bridget Corrigan appears with Jason in this photograph. (Taller.)

On the main wine trail again, Laurello Vineyards, a boutique winery, features some of Ohio's finest award-winning, handcrafted wines. The island of Capri is painted on the wall opposite the entrance to the Italian Mission-style winery. The winery grows five acres of grapes and co-ops with others. It serves antipasto, cheese, crostini, and salads. The motto here is "Wine a bit. You'll feel better." (Taller.)

Ferrante Winery & Ristorante in Harpersfield is a large-scale wine producer with a winery that is a country retreat in the midst of gardens, vineyards, and processing barns. It serves a fine Chardonnay as well as an off-dry Vino Della Casa made from Cayuga and Vidal grapes. The restaurant serves a number of Italian specialties and is a destination for dinner. On the wine trail, travelers save Ferrante for last. (Taller.)

Down the road, Art and Doreen Pietrzyk's St. Joseph Winery makes award-winning Pinot Noir. Their second location was opened in 2008 amongst vineyards planted in 2005. Rough wood floors, high white ceilings, an old woodstove, a small art gallery, and weekend music complete the charm in a tasting room that is not just about wine. (Taller.)

Virant Winery's wines are deep and layered and worthwhile, and the winemaker has been making them since the early 1960s. Inside the door to the left, the tasting bar is a place for the weary to rest on bar stools, but the scenery out the windows is breathtaking, especially at sunset. Red Velvet is the vintner's best-selling wine, and the Chambourcin and Cabernet Franc are award winners. (Taller.)

Chalet Debonne's chalet winery was built from Tony P. Debevc's drawings and has a great room with brick fireplace and floors, an open-air pavilion, and a gazebo. Best known for Riesling and Ice Wine, its Chambourcin is renowned for its quality, and the Cab, a specialty blend, is fruit forward like the company's other wines. The winery won medals at the 2010 World Wine Championship and owns 130 acres of vineyards. (Author.)

Harpersfield is approached by driving through its vineyards to a two-story chateau. The French-styled wines are served in a tasting room with a big stone fireplace and comfortable leather chairs. The winery limits crops on the vine and trims back to get intense flavors. Grapes are picked by hand. Patty Ribic supervises the gardens and food, Wes Gerlosky handles the wines, and Adolph Ribic oversees the vineyards. (Taller.)

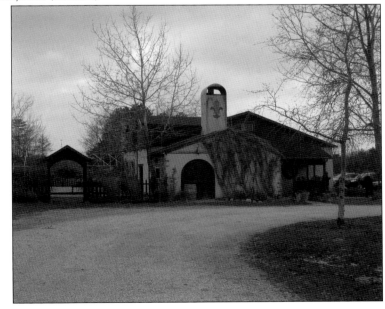

Grand River Winery's wines, like those of Debonne and South River, are crafted by Ed Travis. The winery is set back behind vineyards, not far from the original St. Joseph location. The winery's tiled floors, outside decking, many windows, and European ambience make the experience of sampling a flight of wines with artichoke bake or Brie with pears and crackers outstanding. Its blends, Austin's White and Austin's Red, are well made. (Taller.)

South River Vineyard is found by the steeple of the old chapel that is home to the winery. The vineyard has expanded to 45 acres of vinifera grapes, with plans for more expansion. The estate-bottled wines can be tasted in pews in the sanctuary, which is brightened by stained-glass windows and vaulted ceilings. The most popular wines are Karma, Trinity, and Exodus, and the winemaker blends juice to create unique wines. (Taller.)

Maple Ridge Vineyard is down a gravel road with no roadside sign. Knowledgeable enologist Patty Iubelt uses organic processes and ingredients and chooses the "most natural and least harmful direction." Jim Iubelt hosts wine tastings behind the bar in their European-styled winery where the focus is on sharing the wine. The Limberger and Pinot Noir are exceptionally good, and the winery sells out every year. New vintages are introduced before Christmas. (Taller.)

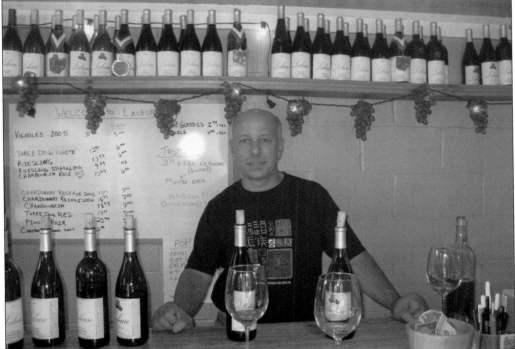

At Laleure, varieties of wine include Pinot Noir, Chardonnay, Cabernet Franc, Riesling, Vignoles, Chambourcin, and Bianco for blending, and wine is fermented in old milk bins. The winery makes 5,000 bottles of wine a year, many of them opened on the property and consumed with food brought in by customers. The Laleure dogs on the property are descendants of the Markko dogs. (Taller.)

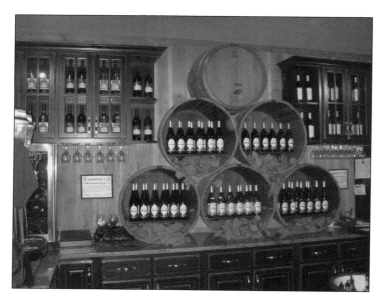

The Winery at Spring Hill, in Geneva, produces premium viniferas and French hybrids, a Covered Bridge series of labrusca, and fruit wines. The wine is bottled on-site and served with heavy appetizers. A gift shop sells local goods, and a side room contains farm-market relics. The company uses all Lake Erie grapes and tries to capture the history with the fruit. Its motto is "Our heritage is our fruit, our legacy fine wine." (Taller.)

Northward, on the lake, roaring waves are background music at the Lakehouse Inn. The outside deck overlooking the water and the windowed patio are relaxing for drinking Cabernet Franc, Boxers Blush, the popular Riesling, or signature Red Sky wine made by Sam Fagnilli and his son-in-law Lance Bushweiler. Since the kitchen is open to the dining room, diners can watch the chef prepare Lake Erie perch. (Photograph by Gayle Absi.)

Old Firehouse Winery serves up views of Lake Erie with its award-winning wines. The winery crafts sweet to dry wines from Sweet Concord to Seyval Blanc on the white spectrum and Vidal ice wine to Chambourcin on the right side of the menu. The historic Erieview Park Ferris wheel dates to 1956 and sits next to the Sunset Patio, where families can enjoy themselves during a summer sojourn at Geneva-on-the-Lake. (Taller.)

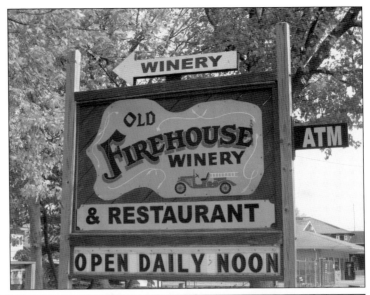

At Bene Vino, the wines go through two fermentations and are made from harvests in both the northern and southern hemispheres. Although the outside looks like a warehouse, the inside is inviting, with tables lit by candlelight and a view of the wine cellar. The wine is good—at Bene Vino, it's all about the wine—and food can be brought in until the winery is set up to serve food. The Malbec, Cabernet Sauvignon, Villaggio Rosso (a tribute to regional grapes), and Villaggio Bianco (from Niagara grapes) are the ones to try. (Author.)

Wineries present opportunities for friends and family to get together while making discoveries of new wines. The wine trails show people the differences in wineries and philosophies and the uniqueness of wines that reflect an enologist's style and tastes. The trails also provide an opportunity to see the countryside. This photograph shows people enjoying wine at Markko Vineyard in Conneaut under a sign that reads, "Gladden the Heart." (Taller.)

Nine

Lake Erie Shores and Islands Wine Trail Today

The Lake Erie Shores & Islands Wine Trail today stretches from Bryan, near the Ohio border, to Westlake and includes the Lake Erie Islands. The area is a prime bird-watching territory because the marshlands and forests are home to blue herons and eagles and are along two major migratory routes. The trail was originally named the Wing Watch & Wine Trail. The climate is perfect for native vines, French-American hybrids, and European varietals.

The wineries range from a dining experience to a small tasting room where wine can be sampled and purchased for consumption off-premises. Some of the wineries are worth visiting because of their historic significance, while others are noteworthy because of the passionate grape growing and winemaking that permeates the location.

This tour starts near the Ohio border and moves toward Cleveland. As with the Vines and Wines Trail, the locations of the wineries should be mapped prior to starting out, but the OWPA has done a good job of announcing wineries along the highways, and trail maps are on its website. The wine trail can be traveled in segments: a far west visit, an islands visit, a Sandusky visit, a Vermilion visit, and a Westlake–Avon Lake visit.

The Lake Erie wine trails provide afternoon or weekend adventures with sweeping views of Lake Erie along scenic byways. Food is usually provided, or travelers can provide their own, although a handful of wineries are only about the wine, and visitors may choose to linger in the vineyards rather than the tasting room. A great selection of wine can be enjoyed in cozy tasting rooms or on fresh-air patios. Romantic and rustic dining rooms serve bruschetta, pasta, sandwiches, entrees, and desserts. Serenading accordions, tinkling harps, and acoustic bands provide music while the scent of oven-fresh bread and the faint sour of wine cellars fill the air. The wineries of Lake Erie's shores and islands lull wine lovers into Old World siestas, Lake Erie style.

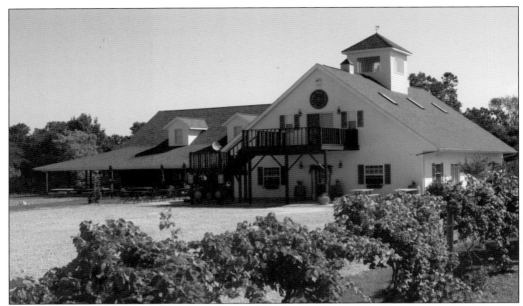

At Stoney Ridge Winery in Bryan, most of the customers are local, with only about 30 percent from tourism. The winery also sells a red, white, and blush Dance series in local stores. The wine is made by co-owner Phil Stotz, whose wife, co-owner Pam Stotz, runs the tasting bar and vineyard operations. A fieldstone fireplace warms the soul in the winter, and the gift shop includes Amish cheeses and gift baskets. Strolling the vineyards is encouraged. (Author.)

The Hillside Winery, in a downtown Gilboa building that used to be a furniture store, has views of a historical bridge. Its Chambourcin, Frontenac, Vidal Blanc, Cabernet Franc, and Riesling wines can be enjoyed by a warm fireplace in the winter or on an outdoor patio in the summer. The winery grows Chambourcin and Vidal Blanc grapes in its vineyards along Riley Creek. (Hillside.)

Near Maumee Bay, Johlin Century Winery's Bolan and Jarrod Johlin have revitalized the business that dates back 140 years to when Jacob Johlin arrived from Germany. The winery once had a 15,000-gallon capacity, but that now fluctuates between 2,000 and 5,000 gallons of vitis labrusca wines each year. Winemaker Bolan (pictured here) learned winemaking from his grandfather Richard. Concord is the winemaker's driest wine, while the rest are mead and fruit. Johlin's raspberry wine has won gold, silver, and bronze medals, which are displayed at the winery. (Author.)

A large stone fireplace is the focal point of the tasting room at Chateau Tebeau Winery. The dry Traminette is a refreshing dry white wine, and the Cabernet Franc is a fruity, dry red wine. The company's other products tend to be sweet, except for a crisp Pinot Gris. The winery serves panini, pizza, ciabatta, salad, and a soup du jour conjured up by Mary Tebeau. Bob and Mary Tebeau are gracious hosts. The vineyards are magnificent. (Author.)

Denny and Danielle Smith host dinners on Friday evenings from their 1930s kitchen. They encourage families to picnic with their families on Sunday afternoons at D&D Smith Winery in Norwalk. Danielle has been experimenting with wine for 30 years and tries new flavors, like a seasonal pumpkin. She teaches customers how to make wine and sells winemaking supplies. (Taller.)

Firelands Winery in Sandusky maintains its offices in the Mantey family farmhouse. The Firelands label Cabernet Franc is mellow and smooth with a hint of raspberry, while the Dolcetto is a medium-bodied, fruit-forward wine. The Mantey wines are labrusca: Niagara, Delaware, Pink Catawba, Haute Sauterne, and Concord. The tasting room is large, and the winery tour provides the histories of both the winery and the area. (Firelands.)

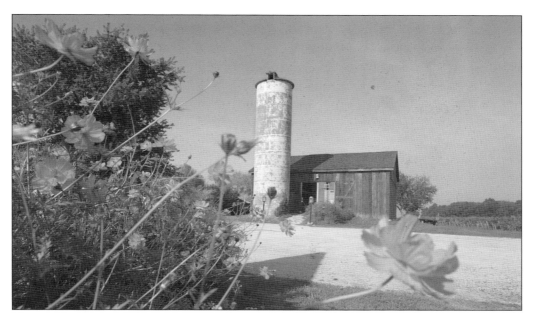

Hermes Vineyards & Winery in Sandusky is modeled after modern French vineyards. The winery densely plants its vineyards to concentrate the fruits. The timber-framed threshing barn is an intimate place for enjoying the company's vinifera wines. White wines include the Semillon and true German Gewürztraminer and Riesling. Red wines include grapes originating from Spain, France, and Italy. All varieties of grapes are grown by Hermes Vineyards. (Courtesy Hermes Vineyards.)

Up on Catawba Island, Mon Ami Restaurant & Historic Winery serves vinifera and labrusca wines, along with sparkling wines and dessert wines, including Catawba, Niagara, Concord, and other varieties. The vitis labrusca–classified Catawba grape is still used in Mon Ami's famous sparkling champagne. The restaurant specializes in seafood (the Saturday buffet is a kingly feast), and the building dates back to 1872. (Author.)

Catch a ferry from Catawba and arrive on South Bass where the Heineman Winery makes fifth-generation wines, including cork hybrids and viniferas. The winery has vine-to-wine quality control year after year because of its 50-acre vineyard. Edward Heineman is the winemaker, and 90 percent of the wine is sold on-site. A majority of the company's grapes are labrusca, and much of that is Catawba. The makers recommend drinking the wine while it is young. (Author.)

A boat ride away, Kelley's Island Wine Co. is in a modern "Australian Outback" bungalow that bears little resemblance to the castle-like structure where winemaking began on Kelley's Island. The Zettlers offer vinifera wines, as well as Sunset Pink and Coyote White, a nod to those sweet island wines. Wine is made on an as-needed basis by Kirt Zettler, and the winery serves casual food. (Author.)

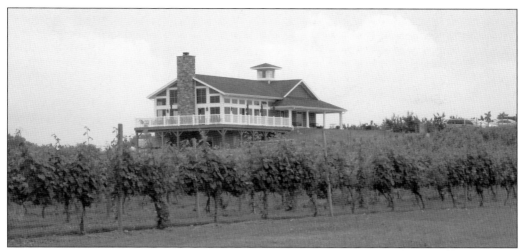

On the mainland in Berlin Heights, Quarry Hill sits high up on a hill with a panoramic view of Lake Erie. The winery produces fruit and native wines, as well as viniferas like Pinot Grigio, Vignoles, and Cabernet Franc. The Framboise's rich, full raspberry flavor makes an excellent dessert wine. Winemaker Mac McLelland loves the vintner lifestyle and the countryside in which he works. The cellar offers self-guided tours, and the winery has a light food menu. (Author.)

Not far from Quarry Hill, Vermilion Valley Vineyards serves Cabernet Franc, Cabernet Sauvignon, Chardonnay, and Riesling, as well as Concord, Niagara, and Pink Catawba in a winery surrounded by vineyards. The windows and porches overlook vineyards and pond. The grapes are too young for wine, so vintners are purchasing wine, except for a small reserve. David Benzinger often leads educational vineyard tours. (Taller.)

Matus Winery contains many old treasures with stories all their own. Winemaker and owner Bob Matus conjures up a great Vidal, and Matus's Riesling is the most popular. The old barn was reattached to the winery, enlarging the rustic space. Much of the building contains recycled items from around the area, like the 1928 bar from an old tavern in Birmingham. In 2008, the moving and addition of the c. 1850 two-story barn began. Wood is original virgin chestnut timber from around 1848. (Matus.)

Paper Moon Winery serves flat bread pizzas and panini in a dining room warmed by a stone fireplace. Wine tastings take place at the bar of the place named after the 1930s song "It's Only a Paper Moon." The Chardonnay is unoaked, the citrusy Twilight Rose is a crowd-pleaser, and the semidry hybrid Chambourcin is co-owner Richard Cawrse's favorite, for good reason. The winery attempts to create a restorative atmosphere and also has an outdoor enclosed patio-porch. (Author.)

Klingshirn Winery in Avon Lake is still a working farm. The first wines cultivated here were native American Concord and Niagara, but winemaker Lee Klingshirn now produces Vidal Blanc, Riesling, Chardonnay, Pinot Grigio, Chambourcin, Cabernets, and Champagne. The tasting room is small and tidy with walls lined by bottles of wine. A walking tour of this winery allows the public to explore the diversity of grapes. (Author.)

At nearby John Christ Winery, most of the vineyards are gone, but the Swiss-style winery remains. A back porch, candle-adorned picnic tables, and fire pits create a rustic European ambience. The winery is sedate in the afternoons and rowdy on weekend evenings when an eclectic crowd drinks a chilled red called Special Blend, berry spritzers, or a refreshing Chardonnay. Award-winning enologist Jack James makes the wines. Bob Malone (left) and manager Dean Gunter are shown in this photograph. (Taller.)

Jilbert Winery specializes in honey wine, and a little-known fact is that the honey opens the palate for the grape wines they sell. This is a winery that happens to have food, and the in-season Saturday night "Chef's Table" may include beef roulade, glazed sweet potatoes, herbed penne pasta, a carrot and black bean medley, and apricot empanadas. The dining room on the top floor of the building is beautiful. (Taller.)

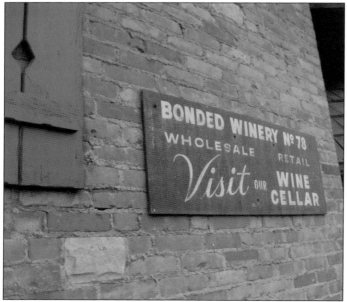

Heartland Wines at J.W. Dover Inc. include Raspberry Melomel, Riesling, Pinot Grigio, Peach Splendor, mead, Cabernet Sauvignon, and apple wine for a total of 23 varieties. The winery also has everything a home winemaker (or home brewer) would need, including 20 types of juices, winemaking kits, pressing bags, and bottles. Much of the company's business is home brewing and winemaking, and the firm recently purchased the label and recipes of Crooked River Brewing Company. (Author.)

Ten

PASSIONATE ABOUT
THE LIFESTYLE

The passion for winemaking and growing grapes continues. In 2009 and 2010, at least eight wineries opened along Lake Erie's shores. Some grow their own grapes, like the Winery at Spring Hill, Vermilion Valley Vineyards, and Chateau Tebeau, while others have decided to make wine and not become farmers.

Not all the new wineries use Lake Erie grapes, and their reasons range from an inability to purchase Lake Erie Appellation grapes to concern about the quality of the grapes grown in the area. The State of Ohio is trying to combat those issues by encouraging vineyard planting to increase the grapes available. The OARDC is working to help cultivate the best grapes possible in Lake Erie shoreline soil, where it does site-specific studies for soil and location.

Whether the new wineries are serving local wine or not, winemakers are passionate about their products. The list of Ohio's Lake Erie wineries grows every year. Each one is unique and has a rich history, founded sometimes on family vineyards and often from home winemaking. The wineries are here to fulfill dreams or continue time-honored traditions. Winemaking is a lifestyle choice, and drinking wine in moderation with meals is an Old Country tradition that America has embraced. Ohio is getting back to its roots by again by growing grapes to make local wines, which enhances the environment.

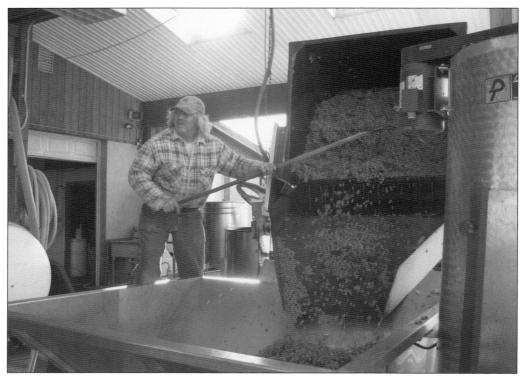

Viticulturists like Ken Tarsitano and Lee Klingshirn would say there is no better way to learn than by getting out in the fields, sometimes volunteering time pruning and tying, as Ken did when he learned from Arnie Esterer and Lee did growing up. Ken said one has to let "the vineyards speak for themselves," which he learned amongst the vines. This photograph is of Lee working with a fresh crop of grapes at Klingshirn Winery during the 2010 harvest. (Author.)

Large wine producers like Firelands Winery and Chalet Debonne distribute wine to a larger audience than most of the wineries in the Lake Erie region. The production of vintage wineries is kept alive by Firelands Winery of Sandusky, where Claudio Salvador produces Dover, Mantey, Lonz, and Mon Ami wines. Anthony P. Debevc of Chalet Debone carries on his family's winemaking tradition and is committed to getting Lake Erie wines out to as many people as possible. (Taller.)

Arnie Esterer says he started a winery because he believes Americans should drink the best wines. He wanted to create a demonstration winery and encourage wine as a food to be used every day. The first wines Arnie made were Chardonnay and Riesling in 1972 and 1973, respectively. Leon Adams, author of *American Wines and Winemaking* and considered a leading wine expert, judged Markko wine as excellent. Esterer believes the future of Ohio wines is in vinifera, the old vines of Europe. He believes that if Ohioans want recognition for Lake Erie wines, they need to have vinifera grapes. Esterer is building an American culture one vine at a time and one glass at a time. (Both, Taller.)

Remnants of grapevines can still be found on Kelley's Island today. These vines were found behind family property of longtime islander Judy DuShane. Like most of the island families, hers was involved in the winery business. Her uncle once managed Monarch Winery. (Author.)

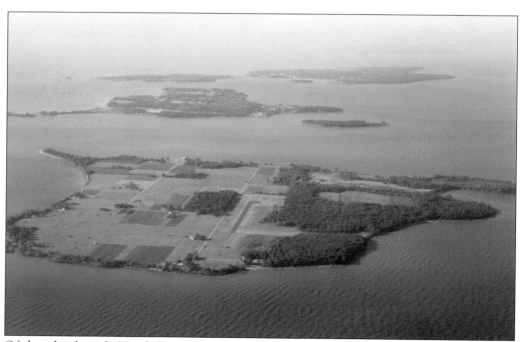

Of the islands, only North Bass Island, owned by the State of Ohio, continues to be highly cultivated in grapes. Some of the 12 families on North Bass are descendants of earlier growers. Robert Gottesman, co-owner of Paramount Distillers, Inc., purchased 400 acres on North Bass Island and cultivated 200 acres of vineyards. Gottesman is credited with sparking a renaissance in Ohio winemaking and planting some of the state's first vinifera grapes. (Firelands.)

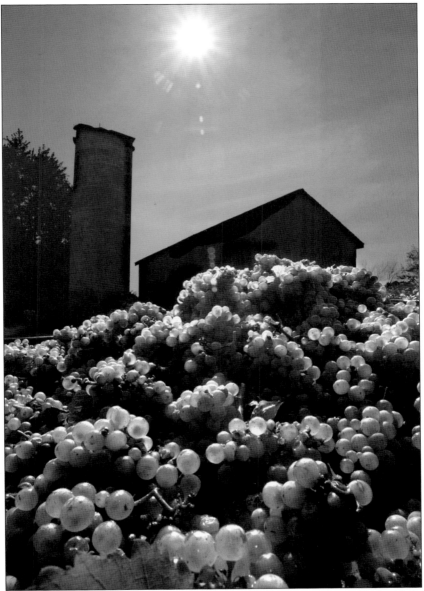

The trend in Ohio is toward more wineries. Quality standards were established by the Ohio Grape Industries Committee and the OARDC's Viticulture and Enology Program. They sought to identify Ohio's highest quality wines made with at least 90 percent Ohio-grown grapes to help consumers develop an appreciation for Ohio's unique flavors. Those vineyards included Markko, Buccia, Tarsitano, Laleure, Klingshirn, and Heartland. While these winemakers agreed to adopt the Lake Erie Quality Assurance label for quality wines, all viticulturists and enologists in the Lake Erie region are committed to quality. With the help of fellow winemakers and grape growers, the Ohio State University Research Center, the OWPA, and the State of Ohio, the demand for local Ohio wines is being met with new vineyards that yield juice and wine that can properly be labeled "Lake Erie." Lake Erie Appellation wineries are listed at http://wine.appellationamerica.com. (Hermes.)

www.arcadiapublishing.com

Discover books about the town where you grew up, the cities where your friends and families live, the town where your parents met, or even that retirement spot you've been dreaming about. Our Web site provides history lovers with exclusive deals, advanced notification about new titles, e-mail alerts of author events, and much more.

MADE IN THE USA

Arcadia Publishing, the leading local history publisher in the United States, is committed to making history accessible and meaningful through publishing books that celebrate and preserve the heritage of America's people and places. Consistent with our mission to preserve history on a local level, this book was printed in South Carolina on American-made paper and manufactured entirely in the United States.

This book carries the accredited Forest Stewardship Council (FSC) label and is printed on 100 percent FSC-certified paper. Products carrying the FSC label are independently certified to assure consumers that they come from forests that are managed to meet the social, economic, and ecological needs of present and future generations.

FSC
Mixed Sources
Product group from well-managed forests and other controlled sources

Cert no. SW-COC-001530
www.fsc.org
© 1996 Forest Stewardship Council

Find Your Place in History.